Close-up & Macro Photography

THE EXPANDED GUIDE

AMMONITE
PRESS

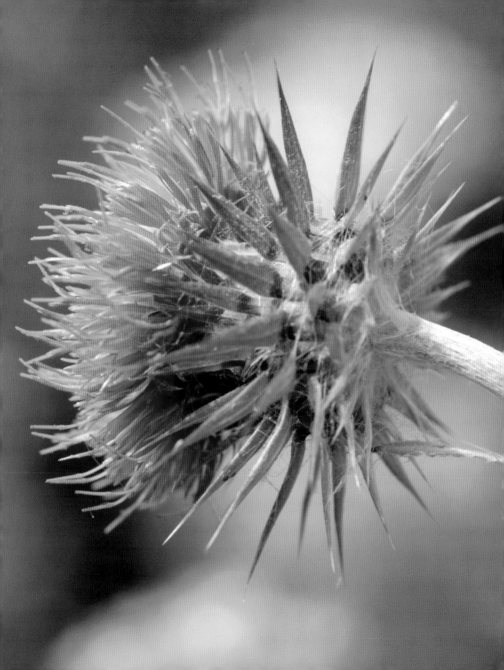

Close-up
& Macro
Photography

THE EXPANDED GUIDE

Tracy Hallett

AMMONITE
PRESS

First published 2011 by
Ammonite Press
an imprint of AE Publications Ltd
166 High Street, Lewes, East Sussex, BN7 1XU, United Kingdom

Text © AE Publications Ltd, 2011
Illustrative photography © Tracy Hallett, 2011 (except
where indicated)
Front cover photograph © Ross Hoddinott, 2011
© Copyright in the Work AE Publications Ltd, 2011

ISBN 978-1-90770-800-8

Series Editor: Richard Wiles
Design: Richard Dewing Associates

Typeset in Frutiger
Color reproduction by GMC Reprographics
Printed and bound in China by Hing Yip Printing Co. Ltd

Page 2
When you become a close-up
photographer small details, such as
the spikes on a musk thistle, leap
out at you.

CONTENTS

Chapter 1	Introduction	6
Chapter 2	Equipment	14
Chapter 3	Exposure and metering	46
Chapter 4	Focusing	66
Chapter 5	Understanding light	76
Chapter 6	Flash	96
Chapter 7	Composition	106
Chapter 8	Color	136
Chapter 9	Project ideas	148
Chapter 10	Post processing	166
	Glossary	186
	Useful web sites	189
	Index	190

CHAPTER 1 INTRODUCTION

Defining the terms

Imagine that you see a mushroom growing in a wood. You walk past it. Your dog investigates it with his nose. Your son or daughter tries to touch it, eyes wide with fascination. When you get home you try to describe it to someone, but all you can remember is that the mushroom was red. Now imagine the same subject seen through the eyes of a close-up or macro photographer.

The red cap of the mushroom, dotted with white, indicates that this is a Fly Agaric (*Amanita muscaria*). You know from the field guide that the white specks are the remains of the veil that once covered the fruiting body. Having crouched down to study the gills from underneath, you notice that they do not quite touch the stem. There is a chunk missing from the cap—the circular bite suggests the work of a horse, no doubt dissuaded from eating the whole by its legendary poison.

When you're on the ground, you can smell the decaying vegetation surrounding the base of the mushroom. You can also feel the damp leaves against your skin, leaving a grubby imprint on your knees. Rising to your feet, you scan the surrounding landscape and note that the Fly Agarics all sprout under birch trees. All of this information forms the background to your picture.

As you set up your tripod, camera and lens, the smells, sounds, and subtle details guide your composition. Now, when someone asks you to describe what you saw, you delight in transporting him or her back to that clearing in the wood, without even leaving home. You perform this clever trick when you show them your photograph.

Childlike curiosity

Close-up and macro photography requires the adoption of a childlike curiosity. By thoroughly exploring a subject we can begin to understand its intricate beauty—we notice the curve of a shell on the beach, or the complementary colors of neighboring flowers. Furthermore, by remaining receptive, we allow the subject to dictate our photographic approach. If, for example, the shell has a mark that threatens to dominate the picture, we shift our composition to eliminate this imperfection. Similarly, if the flowers are blowing too violently in the wind, we create a homemade windbreak to arrest their movement.

While we must learn to respond to the subject, we must also understand how to control as many of the variables as possible. One of the many joys of close-up and

FLY AGARIC
Learning all you can about your subject allows you to photograph it in an informed, imaginative way.

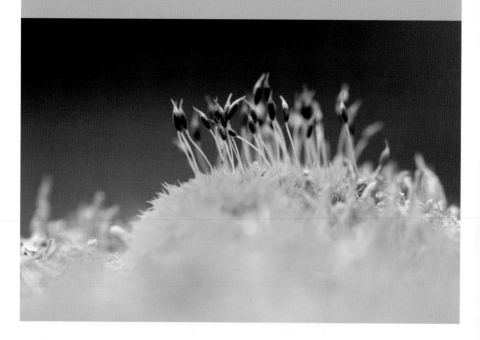

macro photography is the size of the stage on which we perform. While landscape photographers sweat and stress over the shape of a distant tree and the condition of foreground flowers, close-up and macro photographers have the advantage of working on a much smaller scale.

Most of the time distracting elements can be played down, or removed altogether to improve the composition. But that's not to say that close-up and macro photography is without its challenges—far from it.

Technical proficiency

Many great images appear to have been created intuitively, but in reality they are the result of good photographic technique, combined with personal style and vision. Learning how to use the equipment at our

CLOSE-UP
A reproduction ratio below 1:1 (life-size) is classed as close-up, not macro.

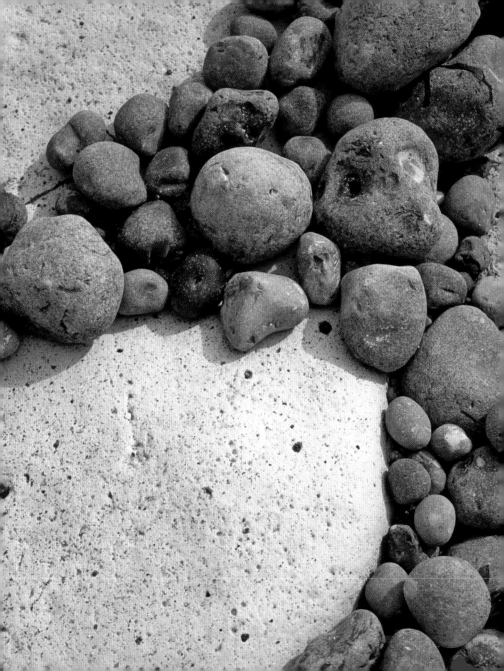

disposal, whether we own a top-of-the-range large format camera, or a low-budget compact camera, enables us to communicate our vision effectively.

Just as a painter knows which brush to use to create a certain effect, a photographer knows which lens, aperture and shutter speed will best deliver his message to the viewer. In time these choices become intuitive. Whether you decide to use 35mm film or medium format digital equipment, the decisions over depth of field, focusing, and lighting often remain the same. While this book mainly focuses on digital equipment, the methodology, fieldcraft, theories, and compositional techniques are equally as relevant to film users.

Coming to terms

Before going any further, it's important to understand some of the terminology used in macro and close-up photography. Although the terms close-up and macro photography are often used interchangeably, in reality only a reproduction ratio of 1:1, or a magnification of 1x (life-size), can be classed as macro; anything less than that is simply classed as close-up.

To clarify things further, the term reproduction ratio is used to describe the relationship between the size of the subject in real life, and the size it is recorded on the sensor (or film). For example, a reproduction ratio of 1:2 means that the subject will appear half its actual size on the sensor or film, whereas a reproduction ratio of 2:1 means that the subject will appear twice its actual size on the sensor (or film).

Finally, magnification is simply another way of expressing the reproduction ratio. If, for example, the reproduction ratio is 1:2, the magnification factor will be 0.5x, whereas a reproduction ratio of 2:1 will have a magnification factor of 2x. Things get more complicated when you move beyond 10x life-size and enter the realms of microphotography—the techniques and tools required for this particular genre are beyond the scope of this book.

Revealing a hidden world

Let's return to our mushroom. This time we will not pass it by. Spending a few moments studying the texture, patterns, and structure of this fungus, leads us to hundreds of ideas for close-up images. By adopting the inquisitive mind of a child, we have entered a hidden world. In this small kingdom beetles and bugs shelter from the rain in the curl of a fallen leaf, while slugs leave a decorative, silvery trail across the grass. These beautiful events are quite ordinary, but with the help of a camera, we can begin to explore, and record, them in an extraordinary way. Perhaps more importantly we can share this vision with others, helping them to understand the intricacies of the miniature world, and the sheer joy of close-up and macro photography.

STUDY TIME
Spending time studying the texture and patterns of the natural world can lead to hundreds of ideas for close-up images.

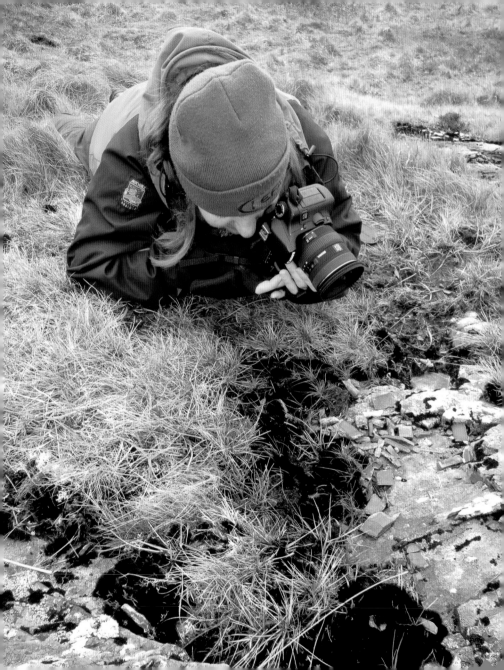

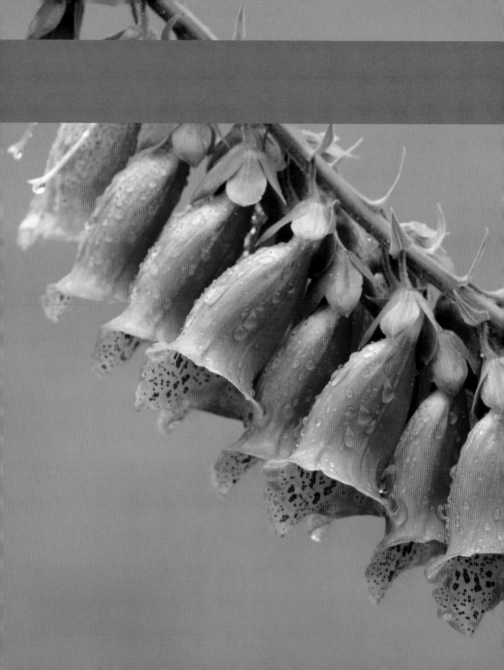

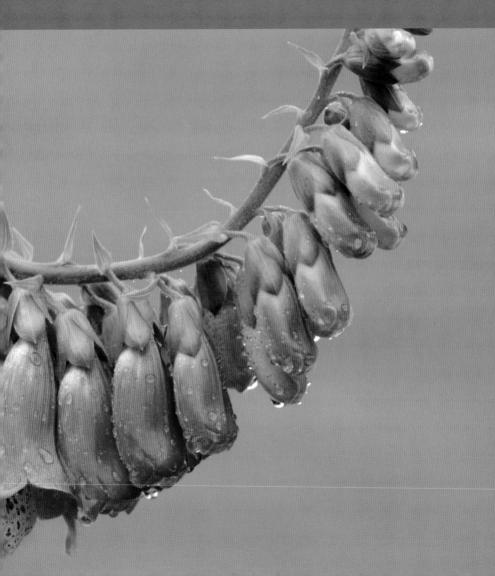

CHAPTER 2 EQUIPMENT

Choosing the right equipment

Close-up photography is a specialized subject, but that's not to say that all of the equipment used to produce frame-filling pictures needs to be expensive or overly complicated. However, there are a few items that do require a large outlay—namely cameras and lenses.

Digital compact cameras

Most households own at least one compact camera; they are light, small enough to fit in your pocket, and relatively cheap. If you want to be sure that you never miss a photo opportunity, the portability and ruggedness of compacts make them ideal for everyday use. However, compacts have a built-in zoom, limiting the focal length you can select. Manufacturers like to impress potential customers by using terms such as 10x digital zoom, but what you're really looking for is an impressive optical zoom. The difference between optical and digital zoom is fairly straightforward: quality. Optical zooms use the lens to draw the subject closer; digital zooms crop a portion of the image and enlarge it—often resulting in a loss of image quality.

Furthermore, some compacts suffer from a condition known as parallax error. What this means is that when you look through the viewfinder, what you are seeing is not exactly what the lens is seeing—resulting in images

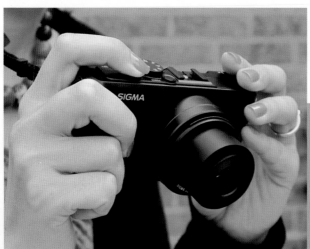

© Daniel Calder

TOP OF THE RANGE
High-end compacts, such as the Sigma DP2, offer an impressive array of manual controls.

that don't precisely match those you composed. While this is not a problem for distant subjects, the effect will be exaggerated for close-ups. On the plus side, parallax error can be overcome by framing your pictures using the LCD screen on the back of the camera.

Compacts are often referred to as point-and-shoot cameras, a name that hints at the amount of automatic decisions these models make on your behalf. However, these tools have come a long way in recent years, and the amount of automation that can now be overridden is impressive. On the latest models photographers can change ISO sensitivity, aperture size, shutter speed, and file size at the touch of a button. Many top-end models now offer a resolution of 10 megapixels or more, making them ideal for large reproductions. While they might not offer the same flexible features as a DSLR (although some models now feature interchangeable lenses), compacts win hands down when it comes to portability, ease of use, and price.

What to look out for...

If you decide to use a compact for close-ups, consider the following:

- *Check that the LCD screen is 2.5in (63.5mm) or more—it's also useful if it's articulated*
- *Look for an optical zoom of x2.5 or more*
- *Find out if parallax error is likely to be a problem*
- *Look for a variety of manual settings*
- *Check if the camera has a close-up or "macro'" mode.*

GET CREATIVE WITH A COMPACT
Close-up images can be taken with a compact camera—if you're willing to experiment.

© Daniel Calder

Bridge cameras

As the name suggests, bridge cameras fill the gap between compacts and DSLRs. Borrowing the rugged, professional-looking exterior of their more advanced cousins, these cameras are often lighter and come with a fixed lens. While the inability to use different lenses might not seem like much of an advantage, the fixed lenses on bridge cameras have been designed to accommodate extensive focal ranges. At the short end of the lens wide-angle pictures are possible; while at the long end telephoto images can easily be obtained. In addition, a fixed lens removes the need for sensor cleaning, as the interior of the camera is never exposed to the elements.

On the flip side, a fixed-lens will never be able to offer the flexibility that an interchangeable lens system provides. Despite this shortfall, bridge cameras are generally very versatile. Photographers can change ISO sensitivity, aperture size, shutter speed, file size, white balance, and metering systems with ease. Furthermore, modern bridge cameras offer both Live View and an electronic viewfinder. These options mean that the photographer sees exactly what will be recorded, eliminating the problem of parallax error found on some compact cameras. Predictably, these electronic advances have a downside: constant use of Live View can drain battery power quickly, while the LCD screen can be tricky to see in bright sunlight.

What to look out for...

If you decide to use a bridge camera for close-ups, consider the following:

- *Check that the LCD screen is 2.5in (63.5mm) or more—it's also useful if it's articulated*
- *Look for a variety of manual settings*
- *Search for a close-up or "macro" mode*
- *Look for a selection of exposure and metering modes.*

NIKON COOLPIX P100
Many bridge cameras, such as the Nikon Coolpix P100, have a variety of semiautomated settings, including Aperture priority (Av) helping you to control depth of field.

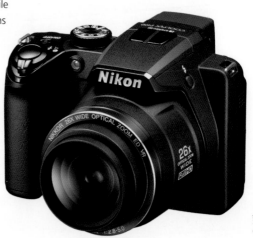

Digital SLR (single-lens-reflex cameras)

While generally heavier and more expensive than compact and bridge cameras, DSLRs pack a whole host of incredible features into a robust, contoured body. Thanks to some clever engineering, photographers can manually control every aspect of the picture-taking process, from ISO sensitivity to metering, focusing, and drive modes. These functions can be accessed easily, while the less commonly used features are hidden away in electronic menus. In addition, DSLRs do not suffer from parallax error. Thanks to an internal mirror and pentaprism, what you see through the viewfinder is almost exactly what you get in the final image (give or take a few percent). This is a great help when you are focusing precisely or using filters. These benefits aside, the main advantage of a DSLR is the ability to change lenses. From 14mm super wide-angle, to 105mm macro, and 600mm super telephoto,

the choice of optics and accessories is extensive. In addition, DSLRs can be teamed with various close-up accessories including extension tubes, reversing rings, and teleconverters.

There are a number of features to look for when you're considering a DSLR for close-up

What to look out for...

If you decide to use a DSLR for close-ups, consider the following:

- *Check that the LCD screen is 2.5in (63.5mm) or more—it's also useful if it's articulated*
- *Look for a selection of exposure and metering modes*
- *Consider how easy it is to override the automatic settings*
- *Search for a close-up or "macro" mode*
- *Consider the focusing options*
- *Check that the camera has a depth-of-field preview button*
- *Look for the mirror lockup facility.*

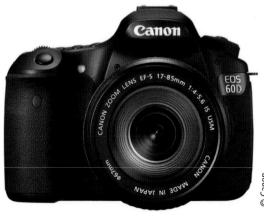

© Canon

CANON EOS 60D DSLR
By using the depth-of-field preview button on DSLRs such as the Canon EOS 60D you can asses how much of the scene will appear in focus before releasing the shutter.

photography. Firstly, check whether or not the camera has a depth-of-field preview button—using manual focus will help you to assess how much of the scene will appear in focus before releasing the shutter. Secondly, see how easy it is to find the mirror lockup function—when used in conjunction with a tripod and remote release, this will significantly reduce vibrations inside the camera. Thirdly, make sure that the available focusing options include manual focus (MF) as well as autofocus (AF)—this will prevent the lens from zooming in and out trying to "lock on" to a subject. Finally, see how easy it is to override the automatic and semiautomatic settings—being able to switch between metering modes, for example, will offer far greater creativity.

STAY FOCUSED
Switching to Manual Focus (MF) will prevent the lens from zooming in and out trying to "lock on" to a subject.

Introduction to lenses

Having spent a small fortune on a DSLR, it's tempting to make cutbacks when it comes to buying lenses. At this point, it's worth remembering that your camera is only as good as the lens you attach to the front of it, so it's a good idea to invest in high-end optics—even if you can only afford to buy one. When it comes to close-up photography, by far the best choice is a macro lens. However, these lenses are not always suitable for general photography (landscapes, portraits etc). As a result, it's worth teaming a less specialized lens (such as a standard zoom) with close-up accessories (such as extension tubes or reversing rings) if you plan on shooting other subjects. Whichever lens you decide to buy, pay particular attention to its minimum focusing distance (this will be listed in the specifications). If you try to focus on a subject closer than the recommended distance, the autofocus system on your DSLR may struggle to "lock on" leading to out of focus images.

Focal length

The focal length of a lens is measured in millimeters, and describes the distance between the optical center of the lens and the focal plane (film/sensor) when the lens is focused at infinity. The focal length determines how much the lens can see (angle of view) and, as a result, how magnified the subject will appear in the frame.

Generally, focal length can be divided into three categories: wide-angle, standard, and telephoto. Wide-angle lenses have a short

focal length and a wide angle of view, whereas telephoto lenses have a long focal length and a narrow angle of view. Despite common belief, the physical focal length of a lens never changes. However, due to the crop factor on APS-C sensors the apparent field of view changes, making the lens appear to increase in focal length.

Crop factors

Many DSLRs contain sensors smaller than full-frame 35mm format. As a result, when attached to the camera, many lenses experience a reduction in the angle of view, making them appear to have a longer focal length. The difference between the two formats is usually 1.6x. This figure is often referred to as the crop or "magnification" factor. When using telephoto lenses, this 1.6x factor is a blessing as it can effectively turn a zoom lens into a telephoto. On the flip side, photographers using wide-angle lenses may need to invest in ultra wide-angle optics just to obtain a standard wide-angle effect.

Angle of view

The angle (or field) of view is measured in degrees (°), and describes how much of the subject is "seen" by the lens and projected onto the sensor. This figure is determined by the focal length of the lens (see above) and the size of the sensor. As their name suggests, wide-angle lenses have a wide angle of view, enabling you to include more in the frame than a telephoto lens, which has a narrow angle of view.

Wide-angle lenses

Thanks to their ability to exaggerate foreground features while offering extensive depth of field, wide-angle lenses are popular with landscape photographers, but often overlooked by close-up enthusiasts. While they may be designed for the "bigger" picture these optics have two clear uses in close-up photography. Firstly, their short minimum focusing distance (usually around 24cm/9.4in) makes it possible to get close to plants, fungi, and other non-sensitive subjects. Using this approach, foreground objects can be made to look larger than life. Flower photographers, for example, will often lie flat on the ground, shooting up at their subject to give it the appearance of a towering skyscraper. Secondly, due to the extensive depth-of-field, wide-angle lenses are perfect for placing a subject within its natural environment. Fungi, for example, are often dependent on the surrounding vegetation to live and thrive, so

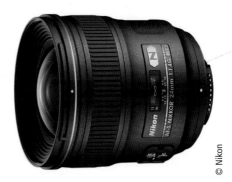

© Nikon

NIKON AF-S NIKKOR 24MM F/1.4G ED WIDE-ANGLE LENS

it makes sense to include their habitat in the photograph. For the best results, stay low and position your subject to the left or right of the frame to include as much of the background detail as possible.

Despite their benefits, wide-angle lenses should be used with care. One of their main advantages is that they appear to exaggerate perspective. As a result, elements in the frame seem to be miles apart, even when they are very close together. This optical illusion can leave your subject floating in acres of space— the shorter the focal length of the lens, the more extreme this distortion will be.

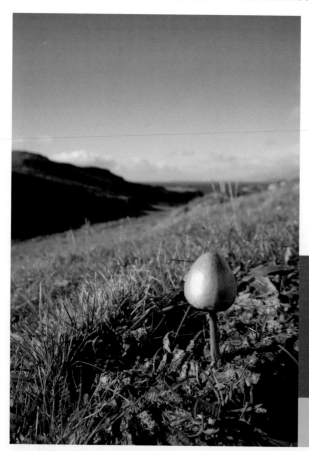

NATURAL ENVIRONMENT
Wide-angle lenses can be used to exaggerate foreground elements, while giving context to natural subjects such as plants and fungi.

Canon EOS 40D, 10–20mm lens, 1/200 sec. at f/8, ISO 100

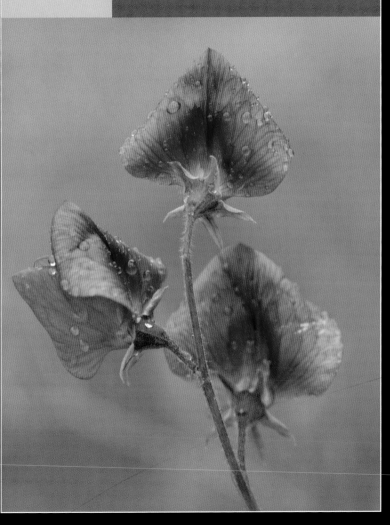

Telephoto lenses

Telephoto lenses have a narrow angle of view, making them appear to magnify objects in the frame—much like a telescope. As a result, frame-filling pictures can be obtained at greater working distances than standard lenses, which is great for capturing sensitive subjects such as damselflies and reptiles. In 35mm terms, any lens with a focal length greater than 50mm is classed as a telephoto, but due to the crop factor on APS-C sensors shorter, more affordable, lenses can be used to achieve similar results.

Telephotos compress perspective (an effect otherwise known as foreshortening) and provide a relatively shallow depth of field—especially at wide apertures such as f/4 and f/5.6. Due to this limited zone of sharpness, telephotos are ideal for isolating a subject against a soft, blurry background or foreground. On the flip side,

shallow depth of field increases the need for accurate focusing, so handholding a telephoto lens is rarely an option. In addition, these lenses tend to be rather large and heavy, confirming the need for a tripod or other firm support. Thankfully, many telephotos come with image stabilization (IS), but this superior technology is matched by a hefty price tag.

Telephoto lenses are available in fixed focal lengths or variable focal lengths (otherwise known as telezooms). Long focal lengths are available (such as 100–400mm) but these tend to have greater minimum focusing distances (3.2–6.5ft/1–2 meters) and are less useful for close-up work. Teaming a short telephoto lens (or medium telezoom lens) with an extension tube *(see page 30)* is a great way of reducing the minimum focusing distance, and increasing magnification.

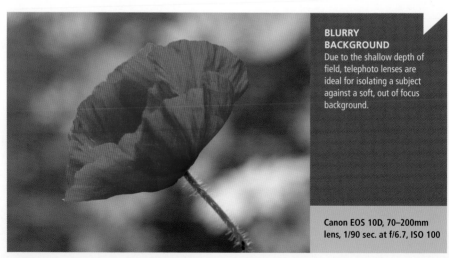

BLURRY BACKGROUND
Due to the shallow depth of field, telephoto lenses are ideal for isolating a subject against a soft, out of focus background.

Canon EOS 10D, 70–200mm lens, 1/90 sec. at f/6.7, ISO 100

Standard lenses

In the past, a 50mm (or standard) lens was often supplied as a kit lens for film cameras as its angle of view roughly matches that of the human eye. Standard lenses offer generously wide apertures, and do not exaggerate foregrounds or compress focal planes—making them ideal for "straight" close-ups. In addition, standard lenses can be teamed with extension tubes and/or reversing rings to reduce the minimum focusing distance.

Due to the crop factor on APS-C sensors you will need a 35mm lens to get the same effect as a 50mm lens. Zoom lenses that include the standard focal length within their range are often referred to as standard zooms.

© Nikon

NIKON AF-S NIKKOR 50MM F/1.4G LENS

GET CLOSER
Standard lenses can be teamed with extension tubes and/or reversing rings to reduce the minimum focusing distance.

Canon EOS 10D, 50mm lens,
1/125 sec. at f/3.5, ISO 400

Prime lenses

As the name suggests, fixed focal length (or prime) lenses have no zooming function, restricting them to a single focal length. These optics, however, tend to feature larger maximum apertures than zooms (covering the same focal length range) making them ideal for handholding. Limiting yourself to a single prime lens is a great way to get your feet moving!

© Canon

CANON EF 35MM F/1.4L USM PRIME LENS

Zoom lenses

Due to their variable focal length, zoom lenses allow you to make the subject appear larger or smaller in the frame simply by turning a ring on the barrel. Aside from the obvious compositional benefits, a zoom lens can often take the place of two or three prime lenses, saving space and reducing weight in your kit bag. For general photography, focal ranges of 24–70mm and 70–200mm are ideal, however, due to the crop factor on APS-C sensors you will need to purchase shorter lenses to achieve the same range. While many zooms feature a "macro" setting, this feature is more accurately

described as "close-up" as it will not permit 1:1 magnification.

In the past, photographers chose primes over zooms due to their superior optical quality, but thanks to modern lens technology this is no longer the case. However, on the downside, zoom lenses tend to have smaller apertures than primes in the same focal range, forcing slower shutter speeds, increasing depth of field, and confirming the need for a tripod or other firm support. In addition, these lenses can make photographers lazy—to get closer to a subject move your feet first, and then the zoom ring.

© Canon

CANON EF-S 15–85MM F/3.5–5.6 IS USM ZOOM LENS

Tip

Due to the crop factor many standard zooms appear to magnify a subject, making them ideal for close-up work. However, bear in mind that the minimum focusing distance is unchanged—unless you use a close-up attachment.

Macro lenses

If the budget allows, then a macro lens is an essential piece of kit for close-up photography. These lenses are designed to focus much closer than standard optics, resulting in frame-filling pictures at reproduction ratios between 1:2 (half life-size) and 5:1 (five times life-size), without the need for extension tubes or other close-up accessories. As they are specially designed for close focusing, the optical quality of these lenses is second to none. In addition, many of them can be used for portrait photography.

Macro lenses come in a range of focal lengths, but can generally be described as standard (e.g., 50 or 60mm), short-telephoto (e.g., 90 or 105mm), or long-telephoto (e.g., 200mm). The standard focal lengths are lightweight, and offer the possibility of handholding. However, these lenses have a much wider angle of view than short-telephotos, which means they show more of the surrounding environment—something that can be distracting. Furthermore, standard macros have a short working distance, forcing you to move closer to your subject. This proximity is fine for static objects, such as fruit and fungi, but flighty creatures, such as butterflies and damselflies, are easily disturbed by movement in the vegetation, and will not take kindly to this intrusion. In general, these focal lengths can achieve reproduction ratios of up to 1:2 (half life-size).

Short-telephoto macro lenses

By far the most popular macro lens, a short-telephoto offers a greater working distance than a standard macro lens—making it ideal for capturing insects, reptiles, and other sensitive creatures. Many close-up photographers opt for focal lengths between 90 and 105mm, with 100mm being the most popular.

Short-telephoto lenses have a narrower angle of view than those in the "standard" bracket, and show less of the surrounding environment, which is great for isolating subjects against busy backgrounds. Furthermore, lenses in this group work well with extension tubes, allowing greater magnifications without reducing image quality. In general, they can achieve reproduction ratios of up to 1:1 (life-size).

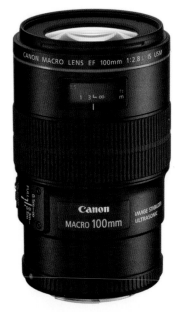

© Canon

CANON EF 100MM F/2.8L MACRO IS USM LENS

Long-telephoto macro lenses

Finally, long-telephoto macro lenses are the optic of choice for photographers looking to dramatically increase working distance, while achieving large magnifications. These lenses have an extremely narrow angle of view, which is ideal for reducing the amount of background in your shot, and transforming what is there into a soft, attractive blur.

On the downside, long-telephoto macro lenses are heavy and should be used with a tripod—some even come with a special collar to support the extra weight. In addition, these lenses are expensive, and less widely available. In general, they can achieve reproduction ratios of up to 5:1 (five times life-size).

When it comes to buying a macro lens, Canon, Nikon, Sigma, Tamron, and Pentax all offer good solid options. Canon offers six choices—five of which can focus to infinity, making them suitable for general photography too. Nikon offers four models including the popular Nikon 200mm f/4D ED-IF AF Micro NIKKOR. Sigma offers four suitable optics, including the Sigma 105mm f/2.8 EX DG Macro (which was the lens used for the majority of the pictures in this book).

GET CLOSER
Dedicated macro lenses are designed to focus much closer than standard optics.

Canon EOS 10D, 105mm lens, 1/180 sec. at f/2.8, ISO 100

Teleconverters

Teleconverters (or extenders/multipliers) fit between the lens and the camera body, and work by increasing the effective focal length of the lens. The most common strengths are 1.4x (increasing focal length by 40%) and 2x (increasing focal length by 100%). These extenders are popular with wildlife and sports photographers since they are lighter and more compact than telephoto lenses, and are relatively inexpensive. In addition, the minimum focusing distance of the lens remains unchanged, making a teleconverter suitable for close-up work. With the working distance effectively increased, you can maintain a suitable distance from sensitive subjects such as insects and reptiles.

As these accessories contain optical elements, there will always be slight degradation in image quality. In addition, teleconverters cause a certain amount of light loss—a 1.4x converter results in a one-stop reduction in light, while a 2x converter causes a two-stop reduction. If you're using a camera with TTL (through-the-lens) metering this loss will be catered for automatically, but it may lead to slower shutter speeds, and consequently the need for a tripod. Furthermore, any loss of light can create problems for autofocus systems, so it's best to switch to manual focus (MF) if the lens appears to be struggling. Some teleconverters are incompatible with certain lenses, so it's best to check before you buy. Finally, you can obtain extra magnification by combining a teleconverter with bellows or an extension tube.

USE MANUAL FOCUS
As extension tubes lead to a loss of light, it's a good idea to switch to manual focus to keep your subject nice and sharp.

Canon EOS 10D, 105mm lens, 1/250 sec. at f/8, ISO 200

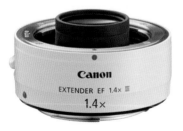

© Canon

CANON EF 1.4X EXTENDER (OR TELECONVERTER)

Extension tubes

Typically sold in sets of three, extension tubes fit between the lens and the camera body, and can be used individually or combined to produce different reproduction ratios. These hollow tubes usually come in three lengths: ½, 1, and 1.4in (12mm, 25mm, and 36mm). They contain no optical elements, and most retain the electrical connection between the lens and the camera. Extension tubes work by physically increasing the distance between the focal plane (sensor/film) and the rear of the lens, reducing the minimum focusing distance, and increasing magnification as a result. The amount of magnification can be determined by dividing the length of the extension tube by the focal length of the lens. Using a 2in (50mm) extension on a 100mm lens, for example, will result in a reproduction ratio of 1:2 (half-size).

Extension tubes have no effect on image quality, but they do cause a certain degree of light loss—the longer the tube, the greater the loss. If you're using a camera with TTL (through-the-lens) metering this reduction will be catered for automatically, but it may lead to slower shutter speeds, and consequently the need for a tripod. Furthermore, any loss of light can create problems for autofocus systems, so it's best to switch to manual focus (MF) if the lens appears to be struggling.

The final drawback comes in the form of working distances—while extension tubes reduce the minimum focusing distance of a lens, moving closer to flighty subjects, such as butterflies, may disturb them, causing them to flee.

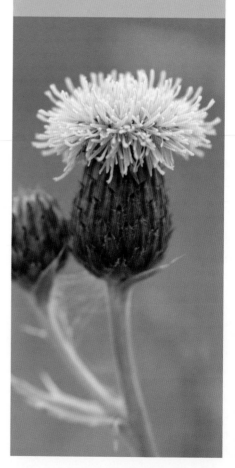

REDUCE THE DISTANCE
Extension tubes reduce the minimum focusing distance of the lens, which is great for static subjects such as flowers and fungi.

Canon EOS 10D, 105mm lens, 1/180 sec. at f/2.8, ISO 100

Close-up attachment lenses

Close-up attachment lenses (also known as supplementary lenses) screw to the front of the lens, and work by slightly reducing the minimum focusing distance, allowing you to focus closer to your subject. These "lenses" act like magnifying glasses and are available in different powers (or diopters). The most common diopters are +1, +2, +3, and +4—the higher the number, the greater the magnification.

Two or more close-up attachments may be used together, but it's worth remembering that the more glass you put in front of the lens, the higher the chance that the image will suffer from some degradation.

Aberration problems

Single-element close-up attachment lenses can cause both chromatic and spherical aberration. The effects of spherical aberration can be reduced by using mid-range apertures (such as f/8 and f/11) but to counteract both of these problems, camera manufacturers such as Canon, Nikon, and Pentax produce double-element close-up attachment lenses—these reduce flare, improve contrast, and correct aberrations.

While close-up attachments may not offer the sharpness and clarity of dedicated macro lenses, they are lightweight, portable, and excellent value for money. In addition, these "lenses" do not reduce the amount of light reaching the sensor, or effect metering and focusing systems. On the downside, unless these "lenses" are paired with short telephoto lenses (such as those in the 150–200mm range) they do not provide enough working distance to photograph sensitive subjects such as insects or reptiles.

SCREW IT ON
Close-up attachment lenses are lightweight, inexpensive, and useful for capturing non-sensitive subjects such as flowers and fungi.

Canon EOS 40D, 105mm lens, 1/100 sec. at f/5.6, ISO 100

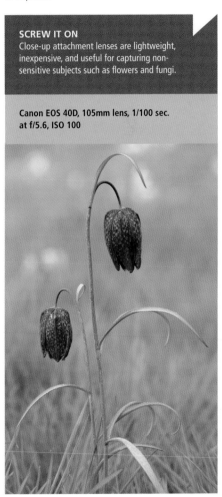

Bellows

Bellows fit between the lens and the camera body, and work in much the same way as extension tubes—by moving the lens physically farther away from the focal plane (the sensor/film) to reduce the minimum focusing distance, and increase magnification as a result. However, unlike extension tubes, bellows are flexible, and allow precise control over the results. As they do not contain any glass elements, these accessories do not affect image quality, but they do create a significant light loss—this will be automatically catered for by TTL (through-the-lens) metering. For the best results, bellows should be used in conjunction with a tripod and focusing rail.

Focusing rails

When you're working with reproduction ratios of 1:1 (life-size) or more, turning the focusing ring on the lens can dramatically alter the emphasis of your photograph. To solve the problem, you can team a tripod with a set of focusing rails (or racks). These rails fit between the tripod head and the bottom of the camera body, and allow you to fine-tune your focusing by moving the camera and lens forwards or backwards as a single unit. This arrangement is ideal for static objects, but no good for active subjects, as even the slightest movement will appear magnified. While focusing rails have their uses "in the field" reproduction ratios higher than 2:1 (twice life-size) are best achieved in the studio, where subject movement is not an issue.

Reversing rings

Reversing rings enable you to mount a lens on your DSLR back-to-front—one end of the ring attaches to the camera body, while the other fits to the filter thread of the front of the lens (which now becomes the back).

As a result of being reversed, the lens will focus much closer to the subject. These rings contain no glass elements, so image quality is unaffected. There is also no light loss for the camera to contend with; however, the electronic contacts will now be on the outside, dramatically reducing communication between the lens and the camera. This leads to a loss in metering systems and automatic aperture stop-down, and can also effect focusing. Thankfully, there are reversing rings on the market that enable you to retain full lens functions. Novoflex (*see page 189*), for example, produces reverse adaptors that allow you to maintain communication between the camera and the lens, permitting autofocus and metering systems to function normally.

Despite the technical drawbacks, reversing rings are a light and relatively inexpensive way to experiment with large magnifications. These adaptors come in various sizes to fit a multitude of lenses (usually with the help of stepping rings) but are most effective on short prime lenses (such as 50mm). Using a reversing ring on a wide-angle lens is inadvisable, as light may become blocked at the edges of the frame, causing vignetting.

Changing your view

Looking at an object through the viewfinder can sometimes cause you to adopt a series of uncomfortable poses, especially when the object is situated at ground level. Luckily, there are a few ways to improve your viewing experience.

Right-angle finder

When your chosen subject lies close to the ground (fungi, plants, sand patterns etc) it can often be awkward to look through the viewfinder without causing yourself back or neck pain—this discomfort can be alleviated by using a right-angle finder. These L-shaped accessories fit to the viewfinder eyepiece and allow the scene to be viewed from above. While they tend to be pricey, some models feature 1x or 2x magnification options, enabling you to check and adjust focus with relative ease. In addition, advanced versions can be rotated 180 or 360°, and occasionally feature dioptric adjustment, allowing spectacle wearers to use

the device without glasses. Right-angle finders produced by the main camera brands tend to be the most expensive, so it's worth looking at options from independents. For the best results, this feature should be used with a tripod-mounted camera.

Articulated LCD screen

Many entry-level DSLRs and top-end compacts feature articulated (or tilt and swivel) LCD screens. This feature is ideal for close-up photography, as it allows the viewing angle to be adjusted to suit the shooting conditions. When the subject is low to the ground, for example, the screen can be flipped out and rotated to allow more comfortable viewing (the camera will need to be displaying "live" images for this to be of use). In addition, an articulated screen is ideal for playing back digital images in bright sunlight, as it can be adjusted to reduce glare and reflections.

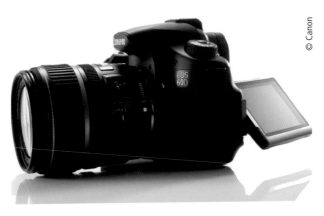

© Canon

TWIST AND TURN
Many DSLRs, such as the Canon EOS 60D, feature an articulated LCD screen, which is ideal for close-up work.

Memory cards and readers

Many PCs now have in-built card readers catering for a number of different memory types (CompactFlash, MemoryStick, Secure Digital etc). As a result, external readers have been pushed to the sidelines in recent years. Despite this relegation, these devices still deserve a place on the photographer's desk. Some external readers are capable of downloading multiple cards simultaneously, while others offer speeds unmatched by serial cables, and even in-built readers. Furthermore, most external readers are so cheap that you can afford to keep up-to-date with new memory formats as and when they appear. While the slots on your computer become obsolete, this device will help you to stay ahead of the game.

Data recovery packages

At some point most of us will hit the "Delete" button and regret it straight away. When you've lost data due to your own bad judgement (accidental deletion or formatting) then a DIY recovery package will allow you to retrieve your files (some memory cards even come with free data recovery software). On the other hand, if your memory card is physically damaged, or you see a "file corruption" message, you may need the services of a professional data recovery company.

Whether you have deleted your data, or suffered a card malfunction, it's tempting to take a few shots just to check that the card is still working. Stop right there. Using the card may seriously hinder the recovery process, so don't be tempted.

MULTIPLE DOWNLOADS
External card readers such as the Delkin Devices ImageRouter allow you to download multiple cards simultaneously.

TAKE CARE OF YOUR CARDS
Protect your memory cards by keeping them in a storage wallet.

© Daniel Calder

Tripods

No self-respecting close-up photographer should be without a tripod. While your handheld images might appear to be sharp on the LCD screen, working with limited depth of field and large magnifications means that any out of focus areas will become obvious once the pictures are enlarged or printed. Aside from the technical advantages, using a tripod will also slow you down and force you to consider your compositions. Furthermore, once the camera is secured to a suitable head, you can make fine adjustments, while using any combination of shutter speed, aperture, and ISO to capture the essence of a scene.

Panasonic DMC-LX3, 24mm lens, f/8, ISO 100

STICK IT IN REVERSE
Using a tripod with a reversible central column will allow you to reach ground-level subjects with ease.

© Daniel Calder

Selecting a tripod

When it comes to choosing a three-legged support, you need to consider minimum height, maximum load, collapsible size, and terrain. Let's look at these variables in turn. Firstly, many close-up subjects occur at ground level; but most tripods are designed for use at waist-level and above. Consequently, no matter how low you collapse the legs, and how far you splay them out, the center column will often prevent you from reaching right down to your subject. To solve the problem, you need a tripod with a removable or reversible central column. (Gitzo, Manfrotto, and Giottos all produce suitable models.)

Secondly, be sure to find a tripod that can bear the weight of your camera equipment. Buying a cheap, lightweight model could prove a false economy when your kit takes a tumble in high winds. To ascertain the maximum load, add the weight of your camera body to that of your longest lens and multiply the result by two—now look for a tripod that can take the weight. (If you do encounter inclement weather, you can often improve the stability of your setup by hooking your camera bag under the central column.)

Thirdly, if you plan to carry your tripod for long distances it's worth checking its minimum size when collapsed, and its overall weight. Carbon fiber models are lighter than their aluminum fellows, but this advantage is reflected in the price. Before choosing one material over another, consider how well each one absorbs vibration, and how durable it is.

Finally, consider the feet. If you regularly shoot on rough or uneven terrain look for a spiked tip to the foot. By contrast, if you shoot indoors, then a rubber tip will prevent your tripod feet from slipping on linoleum floors. Some tripods offer you the best of both worlds, with a removable rubber tip revealing a spiked foot underneath.

> ### Tip
> *For the ultimate strength and support, always extend the sections of a tripod from the top down, and compress it from the bottom up.*

Selecting a tripod head

While your tripod legs provide much-needed stability, pairing them with a cheap, unsuitable head could increase the chance of vibration, leading to out of focus images. Investing in a solid, well-engineered head will allow you to make precise adjustments to focus and composition. (If possible, choose a head to match the make of the legs—this will ensure full compatibility.)

Whether you choose a pan-and-tilt head or a ball-and-socket variety is a matter of personal preference. Pan-and-tilt heads offer movement through two or three axes: tilting forwards and backwards, panning, and/or moving from left to right. The movements of the head are controlled by handles or gears, allowing each axis to be adjusted separately. By contrast, a ball-and-socket head allows movement in all directions,

and can be locked by twisting a screw or lever. Whichever model you choose, look for a head with a quick-release plate, allowing the camera to be attached and detached easily.

Once again, it's important to consider the weight of your equipment. If your gear is too heavy for the tripod head, your camera may droop slightly, destroying your composition. While the physical movement will be slight, it will be exaggerated when working with large magnifications.

LIGHTER ALTERNATIVE
Monopods are lighter and more compact than tripods, but they have limited use for close-up photography.

© Daniel Calder

Beanbags

For low-level shooting, a beanbag is handy, but it doesn't have to stay on the ground—beanbags can also be used on fence posts, car windowsills, or even placed on top of a tripod-mounted camera to reduce vibrations. While they are traditionally used to support the full length of the lens, I often fold mine in half to obtain a little extra height, while nestling the camera body firmly down into the beans. Choosing a beanbag is simple—just decide how much surface area you require, look for tough, showerproof material, and choose a filling that does not hold moisture (such as plastic beads). While the flexibility of a beanbag will never match that of a tripod, it will allow you to be in position and firing away within seconds.

FULL OF BEANS
Beanbags such as The Pandoras Box are ideal for shooting low-level subjects, as they cushion and support your camera and lens.

A matter of posture

If using a tripod is simply not an option, have a go at perfecting your posture. Grip the camera firmly with your right hand, and support the lens from underneath with your left hand. Stand with your legs slightly apart, one foot in front of the other, to increase stability. (Alternatively, if you are crouching down, rest one knee on the ground.) Keep your elbows tucked in to your body. Rest the index finger of your right hand on the shutter-release button. Press the camera lightly against your face and look through the viewfinder. Take the picture after breathing out. If you are still struggling to keep still, rest your body against a steady support such as a wall or pillar. When handholding the camera try to use a shutter speed that at least matches the focal length of the lens. For instance, if your lens is 50mm, then use a shutter speed of 1/60sec.

Keeping your subject steady

Obtaining sharp portraits of plants and insects requires patience, but you can often improve your hit rate by steadying your subject, or, in the case of insects, researching when they will be resting or feeding. One device that will assist in holding your subject steady, is the Wimberley Plamp *(see opposite)*, an articulated arm with a pincer "hand" at one end and a clamp at the other. This multi-purpose device can be used for steadying windblown plants, holding reflectors/diffusers/shades, or repositioning background/foreground objects. The clamp end of the Plamp has been designed to grip a tripod leg, but it works equally well when attached to a branch, fence post, table, or other support.

Clips, string, and wire

Wind is a flower photographer's worst nightmare—anything over 5mph (8kph) and your subject will thrash wildly about the frame, lurching in and out of focus. In order to steady

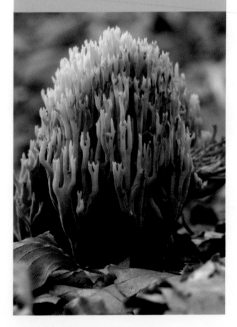

GET DOWN LOW
Ground-level subjects such as fungi can be tricky to reach with a tripod, which is when a beanbag really comes into its own.

Canon EOS 40D, 105mm lens, 1/2 sec. at f/9, ISO 320

attractive blooms, and hold distracting ones out of the way, you can use gardener's string or floristry wire. By pushing a twig into the ground next to your chosen specimen, you can loop the wire or string around the stem and twig, holding the plant in position—just remember to leave the area as you found it.

Preventing vibration

No matter how gently you press the shutter-release button, the internal actions of the camera (and the external actions of the photographer) can still cause vibrations, resulting in out of focus images. Thankfully there are a number of ways to reduce this movement.

Cable release

Pressing the shutter-release button by hand can cause the camera to shake slightly, leading to soft, blurry pictures. To eliminate the problem, you can trigger the shutter from a distance using a cable or remote release. Cable releases plug directly into the camera body and are activated via a button at the end of a lead. By contrast, remote releases use an infrared beam to trigger the shutter. Both of these devices should be used with a tripod-mounted camera.

Self-timer facility

Most cameras, whether DSLR, bridge or compact, feature a self-timer facility. This feature is most often associated with family portraits, where the photographer also appears in the picture. However, the self-timer facility can also be used in place of a remote release when shooting close-ups. By asking the camera to delay firing the shutter, any internal vibration caused by pressing the shutter-release button will have died down before the shutter

EXTRA ARM
The Wimberley Plamp clips to the leg of a tripod and can be used to support plant stems, or to hold reflectors/diffusers or shades.

Canon EOS 40D, 24–105mm lens, 1/4 sec. at f/16, ISO 800

© Daniel Calder

GENTLE RELEASE
When the shutter is triggered using a cable release, vibration inside the camera is significantly reduced.

After waiting a few moments for the vibration to die down, the shutter-release button can then be pressed a second time to expose the sensor or film to light. When the exposure has been made, and the shutter closed, the mirror will return to the viewing position. By locking the mirror in the "up" position, any internal vibration is significantly reduced. For the best results, mirror lockup should be used in conjunction with a tripod, and a cable or remote release.

opens to begin the exposure. For the best results, this feature should be used with a tripod-mounted camera.

Mirror lockup

Every SLR, whether digital or film, contains a reflex mirror that flips up to allow light to reach the sensor or film. During this process the mirror "slaps" the top of the mirror box causing a slight vibration. This vibration dissipates quickly, but the movement is exaggerated when using large magnifications. To solve the problem, many SLRs offer a mirror lockup facility (MLU). When this feature is activated, pressing the shutter-release button once will raise the mirror, holding it in the "up" position.

Tip
Cubes and windbreaks
When a light wind threatens to spoil your shot, it's worth experimenting with a photo cube or homemade windbreak. Photo cubes are often used in studios to soften the light of lamps and flashes. Models such as the Lastolite Cubelite feature an open base, allowing them to be positioned over immovable objects, such as plants. These cubes have the added benefit of diffusing harsh sunlight, resulting in more flattering plant portraits. When it comes to windbreaks, enlist a friend to physically block the breeze with their body (or use the self-timer facility on your camera and do it yourself!). Failing that, fashion a windbreak out of clear polythene and garden canes, and place it to the side of your subject.

CLOSE FOCUSING
To prevent the wind from blowing the orchid
around, I created a windbreak using polythene
sheets and garden canes.

Caring for your equipment

The main threats to your photographic equipment are heat, dust, humidity, cold and human neglect. Thankfully, there are a few simple precautions you can take to ensure that your kit has a long and productive life.

Cosset your camera

If you're not planning on using your camera for a while, remove the battery—if it's left in the camera for long periods it may continue to emit a small current, which may affect its future performance. If you find that the battery drains quickly, even when it has been fully charged, check its recharge performance (if possible) before buying a new unit. When your camera is not in use, store it in a cool, well-ventilated place, away from heat, corrosive chemicals, radio waves, and anything emitting a strong magnetic field.

Interchangeable lenses

Interchangeable lenses should be protected with an ultraviolet (UV) or skylight filter at all times. Try to change lenses as quickly as possible, and protect both front and back elements during the swap. To clean your optics, first hold them upside down and use a blower to remove any loose dust, sand, or dirt. Next, roll a lens tissue into a loose ball and add a few drops of lens cleaning solution to it. (Never use solution designed specifically for eyeglasses.) Do not apply liquid directly to the lens as it can seep along the edges and into the lens itself. Starting at the center of the lens, wipe the glass in circular sweeps, moving towards the outside edge.

Dust prevention

Dust often appears as black splodges or specks in pictures. There are special devices available to remove it, but try a puff with a blower before attempting any serious cleaning. When you clean the sensor what you're actually doing is cleaning the low-pass filter in front of it. However, if you damage the low-pass filter it can be just as costly as damaging the sensor itself. The market is rife with gadgets designed to blow, vacuum, wipe and brush your sensor back to health. Admittedly, some methods require more bravery than others, so always follow the instructions carefully. Before cleaning the filter, make sure that it is actually dirty: dust and debris can appear to be on the sensor when, in fact, it's on the lens, viewfinder, or computer screen. Never use canned air inside the camera body, as the gas can freeze on the sensor. To prevent dust entering your DSLR, switch it off and point it down when you're changing lenses—never swap them in dusty, sandy, or windy environments. It can also help to use a vacuum cleaner to clear out your camera bag now and again. Remember that the sensor is extremely delicate, and if it needs serious attention it should be taken to a specialist repair centre.

Heat and humidity

If your camera is exposed to extreme heat it can cause parts to warp, and lubricating oils to leak. To avoid this happening, never leave the camera next to a radiator, in a car trunk, or close to a heat source.

Transporting your camera from a cool environment into humid conditions, or vice versa, can lead to condensation within the lens. To avoid this happening, place each piece of kit (camera, lens etc) in a ziplock bag or airtight container, and add sachets of silica gel before resealing. As you enter the new climate, the gel will soak up the moisture, and condensation will form on the bag or tub, not on your equipment. Wait for the container to reach the ambient temperature, and then remove your equipment.

Cold conditions

Camera batteries drain quickly when exposed to extremely cold temperatures, resulting in the mechanics of the camera becoming sluggish or ceasing to operate altogether. To avoid such situations, keep your camera close to your body until you are ready to take a picture and store spare batteries in your pockets.

Protection from water

Electronics and water simply do not mix. Unless you are using a special housing, or happen to know otherwise, your camera is not waterproof. If small amounts of rain etc should splash onto your equipment, wipe it off with a clean, dry cloth. Exposing your camera to saltwater, on the other hand, is more serious and can lead to corrosion and malfunction. A day at the beach should result in a thorough clean of your equipment. To prevent exposing your gear to water, invest in a rain cover.

Looking after yourself

Don't forget to take care of yourself when you are out with your camera. Waiting for the wind to die down, or an insect to visit your favorite flower, can involve a lot of hanging around. Always pack more clothes, food and water than you think you need. Don't rely on a GPS system to pinpoint your position, learn how to use a map and compass instead. Always check the weather forecast before setting out, and let someone know your planned route and estimated time of return. (When it comes to wet weather clothing, I use Páramo base layers, trousers, and jackets, *(see page 189.)*

RAIN PROTECTION
A shower-proof camera cover will allow you to carry on shooting whatever the weather.

© Daniel Calder

Bags and carrying systems

Carrying a full complement of photographic gear can be a pain in the neck, not to mention the shoulder and back too. Thankfully there are ways to distribute the weight of your kit, while keeping essential pieces of kit close at hand. While camera bags are the most obvious solution, don't discount waist packs, jackets, vests, and harness systems—each has its own merits and drawbacks.

Selecting a camera bag

When you're looking to buy a camera bag, it's important to consider comfort as well as practical features such as space and the number of internal pockets. If possible, load your chosen bag with at least 4.4lb (2kg) of gear, and try it on before you buy it. Look for reinforcement where you need it most: the base and back—remember that your lenses may well be pointing towards the bottom of the bag, so it needs to be well protected. Consider whether or not you need extra space to carry non-photographic equipment such as car keys, a wallet or snack. If so, look for clear compartment divisions that

will protect your camera gear from any spillages or knocks. Check that the straps and buckles are strong, and easy to secure. Find out how easy they are to replace, and whether the cost is covered by the guarantee before committing yourself. Finally, note how quickly you are able to open the pack and access your equipment—this could mean the difference between getting the shot or missing out.

Camera vests and jackets

There may be occasions when your camera bag feels a little too bulky to carry around all day. In such instances, the thought of popping lenses, cards, and accessories into your pockets may seem attractive. Unfortunately, standard pants and tops simply don't have enough room to accommodate camera kit; for that job you'll need a photographer's vest or jacket. When you're looking for a vest, choose one that falls close to the waistline—anything longer may result in the contents of the lower pockets bashing against your thighs when you walk. Also, consider a built-in waist belt to stop your equipment from swinging around your sides. Remember that vests and jackets can be uncomfortable in hot weather, so look for breathable fabrics and mesh ventilation panels

FULLY LOADED
Before you buy a camera bag, you'd be wise to load it with at least 4.4lb (2kg) of gear, and try it on. Bear in mind how comfortable it would be to carry around all day.

under the arms and on the back. At the same time, check that the shoulders are padded, to relieve the pain of carrying a camera around your neck. It's crucial that the seams are strong enough to take the weight of heavy equipment, so check the pockets for any areas of weakness. Finally, to protect your lenses from rain and perspiration, check that pockets are lined and waterproof.

Mats and groundsheets

Photographing flowers, insects, and fungi often involves lying on the ground for hours on end, leading to wet legs and uncomfortable indentations on the knees! Thankfully, any discomfort can be minimized by using a garden kneeling pad or ground mat. When lying on the grass for extended periods, I use a Linpix Photography Mat *(see page 189)*. This full-length mat is hardwearing and waterproof, and folds in two (keeping the grubby side tucked away) before rolling up

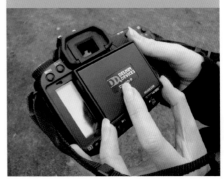

IN THE SHADE
LCD sunshades such as Delkin Devices Pop-Up Shade block out light and reduce glare.

© Daniel Calder

and attaching to the tripod loops on a camera bag. When weight is an issue, I leave the mat at home and opt for a plastic ground sheet instead. Whether you're using a kneeling pad, mat, or ground sheet, be sure to avoid squashing vegetation as you lay yourself and your gear down on the ground.

LCD shade

Viewing an LCD screen in bright sunlight can be problematic. In such conditions histograms become tricky to read, menus impossible to navigate, and Live View and video shooting unfeasible. Using an articulated screen certainly helps, but a detachable sunshade is useful for cameras without such a facility. Models produced by Delkin and Hoodman block out light and reduce glare, making images easier to view, process, and manipulate "in the field."

GROUND COVER
The Linpix Photography Mat is waterproof, offering excellent protection against wet grass.

© Daniel Calder

Understanding exposure

Obtaining a "correct" photographic exposure requires a basic understanding of the relationship between ISO, aperture, and shutter speed.

The ISO determines how sensitive the sensor/film is to light; the aperture (measured in f/stops) describes the size of the hole in the lens through which light passes; and the shutter speed (measured in fractions of a second) refers to the amount of time the light is permitted to hit the sensor/film. Each of these variables is dependent on the other.

All of these factors can be adjusted, providing very different results. Selecting a wide aperture produces shallow depth of field; while a fast shutter speed freezes movement, for example. The role of the ISO is to facilitate these changes. Here, it's important to note that if you alter the aperture, the shutter must be adjusted to compensate. Similarly, if you alter the shutter speed, the aperture must be adjusted.

Light factors

When it comes to light, aperture and shutter speed share one signifcant similarity: each figure allows half or double the amount of light to reach the sensor/film as its immediate neighbor—a shutter speed of 1/250 sec., for example, allows twice as much light in as one of 1/500 sec.; whereas an aperture of f/8 lets in half the amount of light as f/5.6. Similarly, if you halve the ISO speed, the amount of light the

sensor/film requires will double, and vice versa. Of course none of this matters unless you know how much light is being reflected from the subject in the first place.

Metering modes

Every digital camera features metering systems that judge how much light is being reflected from a subject. The photographer uses this information to decide on an appropriate shutter speed and/or aperture for the scene (unless the camera is set to automatic, in which case it will do the calculations for you).

The most common types of metering system are Multi-zone (otherwise known as Evaluative or Matrix metering), Center-weighted average, and Spot metering. The other options, and their uses, are listed overleaf.

TAKING CONTROL
Understanding the relationship between ISO, aperture, and shutter speed means you can control the light reaching the sensor/film and manipulate it to your advantage.

Metering patterns explained

REFLECTED LIGHT READINGS USING AN SLR
Built-in TTL (through-the-lens) light meters measure the light reflected by a subject, and can be found on most SLRs. Having taken a reading, the camera calculates an exposure based on the assumption that the subject has a reflectance and tone equal to 18% (mid-tone) gray.

MULTI-ZONE (EVALUATIVE/MATRIX) METERING
Uses light/brightness readings from zones across the frame (the exact number will depend on the camera model) to help you select the most appropriate aperture/shutter speed combination.

CENTER-WEIGHTED AVERAGE METERING
Measures the light/brightness across the frame, giving emphasis to the center of the viewfinder.

PARTIAL (SELECTIVE) METERING
Takes a reading from a small area in the center of the frame (usually between 6 and 15%) to help you select the most appropriate aperture/shutter speed combination.

SPOT METERING
Measures the light/brightness in a very small area of the frame (usually between 1 and 5%) to help you select the most appropriate aperture/shutter speed combination.

MULTI-SPOT METERING
Is available on a number of camera models and allows you to take a series of spot readings, which are then averaged to help you select the most appropriate aperture/shutter speed combination.

Exposure compensation and bracketing

There are a number of ways to override the camera's in-built meter.

Exposure compensation

There may be occasions when the metering system on your camera is fooled into making an inaccurate exposure—e.g. when faced with an excessively bright or dark subject. In these instances you may need to offer the camera a helping hand.

The easiest way to "correct" under- or overexposure is to use the Exposure compensation facility (this feature is found on many DSLRs, bridge cameras, and compacts). Having taken an initial reading, simply turn the Exposure compensation dial to the left to decrease the exposure (making the scene darker) or to the right to increase exposure (making the scene lighter).

How much you increase or decrease the exposure will depend on what percentage of the scene is occupied by the overly light or dark subject. If you're shooting a small white flower against a backdrop of dark leaves then the amount you need to "dial in" will be marginal. However, if you're shooting a snow scene,

which fills the frame, then the amount you need to dial in will be far greater. Remember to set the exposure compensation back to zero when you have taken your shot, since this facility usually remains active even after the camera has been switched off.

EXPOSURE COMPENSATION
An excessively light subject can trick the in-built light meter into underexposing. Here, an increase of 1-stop was needed to keep the snow bright.

Canon EOS 60D, 24–105mm lens, 1/400 sec. at f/18, ISO 200

Tip
Many cameras will allow you to take an exposure reading and then "lock" it before recomposing the picture.

Autoexposure bracketing

If your camera features an Exposure compensation facility, it is also likely to offer an Autoexposure bracketing option. Setting this feature will instruct the camera to take a sequence of three successive pictures using different exposures: one standard (using the camera's recommended meter reading), one under the suggested reading, and one over the reading. There's no need to reset the bracketing amount to zero, since it's usually canceled when the camera is turned off.

USING BRACKETING
You can instruct the camera to take a sequence of three pictures using different exposures. Here the "overexposed" shot looks best due to the amount of white in the frame.

Canon EOS 40D,
24–105mm lens, 1/60
sec. at f/5.7, ISO 1000

JOINT EFFORT
Autoexposure bracketing can often be used with
Exposure Compensation to help record overly light or
dark subjects accurately.

Understanding ISO

The ISO speed indicates how sensitive the sensor (or film) is to light, and determines how much exposure it requires to record a subject or scene accurately. In short, the higher the ISO speed, the more sensitive the sensor/film is, and the less light it requires.

Generally, high ISO speeds are useful for low-light situations (such as photographing in dense woodland) whereas low ISO speeds are ideal for bright conditions (such as shooting in open sunshine). Increasing the ISO also facilitates faster shutter speeds (which is ideal for reducing camera shake, or freezing a moving subject). Alternatively, the ISO can be raised to allow smaller apertures (increasing depth of field).

While boosting the ISO might sound like a win-win situation, this increased sensitivity often comes at a price. Using speeds of 400 and above can lead to increased levels of noise. Noise is mostly seen in areas of even tone, such as blue skies and dark shadows. To minimize the problem, use the lowest ISO you can for the ambient light levels. When a low ISO is not an option, check to see if your camera has an in-built noise reduction facility. Finally, if all else fails, shoot Raw and use post-production software to clean up the offending areas.

Using a low ISO speed produces crisp images with rich detail and vibrant color. However, as the sensor/film is less sensitive, it needs to be exposed to light for longer, leading to slower shutter speeds and/or wider apertures. While

long shutter speeds are not a problem for static subjects (such as fungi) they are of little use for capturing movement (such as the flight of a butterfly), and handholding your equipment. In addition, the use of wide apertures reduces depth of field, which can be an issue for close-up subjects. However, there may be times when you require a slow shutter speed (when recording water as a milky blur, for example) in which case a low ISO (coupled with a small aperture) is ideal. Alternatively, if you require a fast shutter speed (and the largest aperture available is not enough to allow one) you can boost the ISO to suit your needs. Most cameras have a button to adjust the ISO, and speeds range from 25–1600 or more.

Fact

The relationship between ISO and exposure is simple. When the ISO speed is doubled, the exposure required is halved. For example, ISO 200 needs half the exposure as ISO 100.

Canon EOS 60D,
105mm lens, 1/50 sec.
at f/5, ISO 100 (top);
1/3200 sec. at f/5, ISO
6400 (bottom)

ISO COMPARISON
At ISO 100 noise is minimal
and colors are reproduced accurately. At ISO
6400 "grain" is much more evident.

Understanding shutter speed

Conveying a sense of movement in your photographs requires anticipation, solid technique, quick reactions, and a willingness to experiment. There are three main ways to suggest motion: freezing, blurring, and panning.

When faced with an action sequence (such as a bee collecting pollen), it's easy to respond by selecting a fast shutter speed to freeze the motion, but this is not always the best solution. The human eye views movement as a flowing sequence, therefore to isolate one part of this sequence and freeze it can make the subject appear static. Try to previsualize the effects of freezing, blurring, and panning before making a decision on how to shoot a moving subject.

Freezing

In order to freeze motion, you need a fast shutter speed. Which you choose depends on several factors: the speed at which your subject is moving across the frame; the direction in which it is moving; and the focal length of the lens. For example, a man running parallel to the camera will move more slowly across the frame than a moving car. As a result, the shutter speed required to freeze the runner will be slower than that needed to pause the motion of the car. If the man is running towards the camera, he will be crossing less of the sensor plane, and will require a slower shutter speed than he would if running parallel to the camera. Furthermore, using a long focal length lens will mean that the subject appears larger within the frame, and will take less time to cover the sensor plane than if you were using a wide-angle lens. It is common practice to select the highest shutter speed possible in order to prevent blur from occurring.

Blurring

Blur is commonly used in landscape photography to show water as a milky wash, but it can also be used with other subjects. A tripod is needed to allow slow shutter speeds, while preventing camera shake. Again, the shutter speed required will depend on the speed of the subject. Blur can also be combined with flash—try using a slow shutter speed to create a sense of movement, then freeze the subject with a burst of light.

Panning

Panning involves using a medium shutter speed, following your subject through the viewfinder, and pressing the shutter-release button at the desired point. The subject will remain sharp while the background appears blurred. Panning may require experimenting with various shutter speeds to achieve the desired effect. The result will depend on the speed of the subject, and how far away you are from the action.

Canon EOS 40D, 105mm lens,
1/40 sec. at f/10, ISO 160 (left);
0.3 sec. at f/22, ISO 160 (right)

FREEZE AND BLUR

When shooting water it's a good idea to include a static object (such as a stone or leaf) in the frame to provide a point of reference for the viewer. "Freeze" (left) was taken at 1/40 sec. and "Blur" (right) at 0.3 sec.

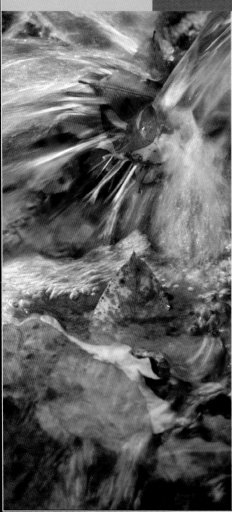
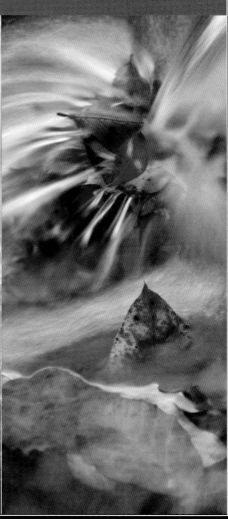

Aperture and depth of field

Depth of field is a term applied to the area of acceptable sharpness within a photograph. In reality, only the element you have focused on—and anything else on the same plane—will be perfectly sharp, but an area in front of and behind will also appear to be sharp.

The range of this sharpness depends on three factors: the aperture of the lens, the chosen focal point, and the subject-to-camera distance. Let's look at each of these variables in turn. Firstly, a wide aperture (indicated by a low f-number) will generally result in shallow depth of field, whereas a narrow aperture (indicated by a high f-number) will result in extensive depth of field. Secondly, the exact point at which you focus the lens will not increase or decrease depth of field per se, but it will affect where the acceptable zone of sharpness begins and ends. Finally, the closer you are to the subject, the less depth of field you will obtain in your pictures, and vice versa.

Depth of field extends from about one third in front of the point you choose to focus on to roughly two thirds behind it. There may be occasions when you want to maximize the depth of field without changing the aperture, subject-to-camera distance, or the focal length of the lens. In these instances, try focusing roughly one third from the bottom of the frame for optimum depth of field. Alternatively, you can use the hyperfocal focusing technique *(see page 68)*.

Thankfully, determining depth of field is not a matter of guesswork. Many cameras come with a depth-of-field preview button *(see page 61)*, which allows you to see exactly what is in focus before releasing the shutter. In addition, many lenses have a distance scale on the lens barrel, to help you make an assessment.

So, in short, to increase depth of field either stop down the aperture (select a higher f-number), step back from the subject, or try focusing one third into the frame. Conversely, to decrease depth of field either use a wider aperture (select a lower f-number), or step closer to the subject. We will look at these variables in more detail over the following pages.

> **Fact**
> *The aperture is measured in f/stops—the smaller the number, the larger the opening: f/2.8, for example, is wider than f/22.*

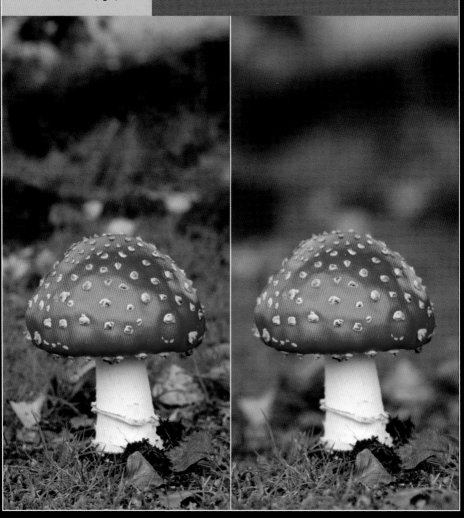

Canon EOS 40D, 105mm lens, 1/8
sec. at f/14, ISO 100 (left); 1/85
sec. at f/4.5, ISO 100 (right).

ALTERING APERTURE
By altering the aperture, you can dramatically change the way the
background appears.

Changing the aperture

In order to expose the film/sensor to light, a series of overlapping metal leaves in the lens creates an opening, called an aperture, which can be widened or narrowed depending on how much exposure is required. The size of this opening is indicated by an f/stop or f/number—the smaller the number, the larger the opening. Aside from controlling the amount of light that reaches the sensor/film, the aperture is also partly responsible for determining depth of field—the wider the aperture, the narrower the depth of field. Using a wide aperture can make a subject stand out from its environment, or take the emphasis off a distracting background. Conversely, using a narrow aperture can give a subject context by placing it within its natural environment, or stress the importance of background details.

Focal point

The point at which you focus your lens does not increase or decrease depth of field per se,

what it does is shift the "zone" of acceptable focus. If you focus on the edge of a petal, for example, the area directly in front and behind the edge will appear in sharp focus. This focus will gradually fall away, until whole areas of the flower appear blurred. However, if you change the point of focus by just a few millimeters, and train your lens on the center of the flower, the edge of the petal will be thrown out of focus, while the center, and the areas directly behind and in front of it, will now appear sharp. As the eye is drawn to detail, it's important to choose your point of focus wisely in order direct the viewer around the frame.

Subject to camera distance

At high magnifications, such as 1:1 (life-size), depth of field is extremely limited—this is exasperated by the fact that the closer you focus the lens, the shallower the "zone" of focus becomes. Consequently, when a macro lens is positioned just centimeters away from a subject, deciding which aperture to use, and where to

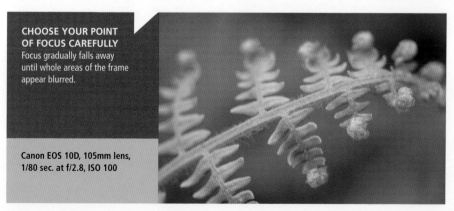

CHOOSE YOUR POINT OF FOCUS CAREFULLY
Focus gradually falls away until whole areas of the frame appear blurred.

Canon EOS 10D, 105mm lens, 1/80 sec. at f/2.8, ISO 100

position the point of focus is crucial. Before making a decision consider where you would like the eye to be drawn to first.

Useful camera modes

While no DSLR is designed specifically for macro photography, most models feature settings and features that can be used to improve close-up techniques.

Aperture Priority (Av) mode

In (Av) Aperture Priority mode (where Av stands for Aperture value) the photographer sets the aperture, and the camera automatically chooses a suitable shutter speed. The aperture you select will depend on how much of the scene you wish to remain acceptably sharp, but, as we have seen, this will be governed by the chosen focal point and the subject-to-camera distance.

Manual (M) mode

In (M) Manual mode (where M stands for Manual) the photographer sets both the aperture and the shutter speed, using an onscreen indicator as a guide. For the ultimate in creative control, this mode can't be beaten. However, for the sake of convenience, many close-up photographers prefer to use semiautomated shooting settings such as (Av) Aperture Priority mode.

Close-up mode

As we have seen, only a reproduction ratio of 1:1, or a magnification of 1x (life size), can be classed as macro; anything less than that is simply close-up. In short, the macro or close-up mode on your compact, DSLR, or bridge camera will not allow true macro magnifications, but it's a good place to start.

Using the close-up mode instructs the camera to set a wide aperture, resulting in a relatively shallow depth of field. As a result, your subject will appear sharp against a blurred background. When light levels are low your in-built flash may pop up, but it can usually be pushed back down if not required.

Depth-of-field-preview button

When you look through the viewfinder you are observing the scene through the widest aperture available on your chosen lens—this enables you to compose your shots with confidence. However, many DSLRs come with a depth-of-field preview button. When this button is pressed the lens stops down to the aperture you have selected, allowing you to see exactly what will appear in focus in the final image. While it might take some getting used to (the viewfinder can become very dark when using small apertures) this feature is excellent for checking the frame for distracting highlights such as glare on foliage, or patches of bare earth.

Focal plane mark

In order to maximize depth of field, keep the plane of focus (indicated by a mark on the camera body) parallel with the subject. (The plane of focus is essentially where the film or sensor sits in the camera.)

Understanding histograms

While the LCD monitor on your digital camera is an excellent way to assess composition, all too often it is also relied upon to judge exposure. When an image is under- or overexposed, a check of the monitor will indicate that adjustments are needed—but when it comes to subtle corrections this screen can prove misleading.

In order to make an accurate assessment of an exposure, you need refer to its histogram. This graph provides a visual representation of the tonal range of an image, from the darkest shadows (shown on the left) to the brightest highlights (shown on the right). The two most common types of histogram are outlined below.

When assessing a histogram, it's important to remember that a high number of pixels on the right-hand side is normal for scenes containing a great deal of light elements (such as snow), whereas a high number of pixels on the left-hand side is normal for scenes containing a great deal of dark elements (such as rocks). When dealing with average scenes, however, try and capture a range of tones, with the majority of pixels to the left of the center point—underexposure is far easier to correct in post-production than overexposure, where detail is irretrievably lost.

The Brightness histogram

The Brightness histogram is a graph showing the overall exposure level of an image. The horizontal axis shows the brightness levels from pure black (on the left) to pure white (on the right). The vertical axis shows how many pixels exist for each level of brightness. In general, if the majority of the peaks are to the left then the image may be underexposed. Conversely, if the majority of the peaks are to the right then the image may be overexposed. If the graph runs off on either side, then it's a good indication that detail will be lost in the shadows or highlights.

The RGB histogram

The RGB histogram is a graph showing the separate brightness levels of red, green, and blue in an image. The horizontal axis shows the brightness level of each color, with its darkest level on the left and its brightest level on the right. The vertical axis shows how many pixels exist for each level of brightness in each color. In general, if the majority of the peaks are to the left then that particular color will be darker and less intense. Conversely, if the majority of the peaks are to the right then the respective color will be brighter, but may lose detail through over saturation.

UNEVEN DISTRIBUTION
When assessing a histogram it's important to remember that a high number of pixels on the left-hand side is quite normal for scenes containing a great deal of dark elements.

EVEN DISTRIBUTION
When dealing with average scenes try to keep the majority of the pixels to the left of the center point of the graph.

Isolating detail

Selecting a wide aperture (such as f/4.5) creates a narrow depth of field, which is ideal for isolating individual flowers against a busy or distracting background. The orchids here were photographed in a greenhouse—providing diffused lighting, while avoiding the problems associated with large magnifications and wind.

Exposure mode: Manual
Sensitivity: ISO 200
Shutter speed: 1/750 sec.
Aperture: f/4.5
Support: Tripod

Dealing with contrast

As the contrast between the dark, dense foliage and bright white petals of the wood anemone might have fooled the camera's meter, I switched to spot metering, took a reading off a nearby patch of grass (which I knew to be mid-tone) and used this information to set the exposure.

Exposure mode: Manual
Sensitivity: ISO 200
Shutter speed: 1/160 sec.
Aperture: f/5
Support: Beanbag

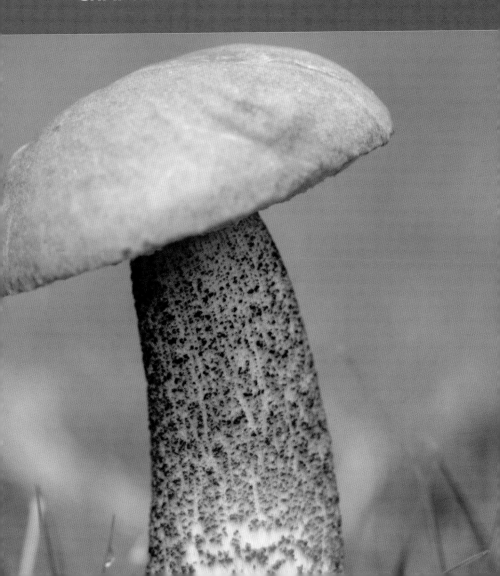

Introduction to focusing

When shooting at close range, depth of field is minimal, and even the smallest aperture will result in just millimeters of acceptable focus. When depth of field is limited, accurate focusing is crucial and you must learn which areas to make sharp, and which to reduce to a blur.

Our eye is naturally drawn to detail, so objects that appear in focus are frequently perceived as more important than those that appear blurred. Unfortunately, the camera is just a machine and, without instruction, has no way of knowing where to place emphasis within the composition. As a result, autofocus (AF) systems often "lock on" to background details or nondescript items close to the center of the frame. To resolve this issue, the photographer has to take full control of the camera.

Focus and depth of field

As we have seen, the chosen focal point is one of three variables to effect depth of field (the other two being the aperture of the lens, and the subject-to-camera distance). In practice, the exact point where we focus the lens will be sharp (along with anything else that falls along the same focal plane) while a certain area in front of and behind this plane will also appear acceptably sharp.

While the point of focus does not actually increase or decrease depth of field, it changes where this zone of reasonable sharpness begins and ends.

Hyperfocal distance

Landscape photographers often focus at least one-third of the way into the frame to avoid "losing" any sharpness in the foreground. However, when a lens is focused to infinity (e.g., the distant horizon), some of this range of sharpness is wasted (only the area one-third of the way in front of the horizon will appear sharp). Consequently, to maximize depth of field photographers employ a technique known as hyperfocal focusing.

This method involves attaching the camera to a tripod and setting a small aperture (large f-number). The lens is then focused to infinity, using the symbol on the barrel as a guide. With the lens trained on the horizon, the photographer can now press the depth-of-field-preview button to ascertain the closest point of the scene that appears sharp (known as the hyperfocal point). Once this has been determined, the lens can be refocused to this distance before the shutter is triggered. This technique will allow you to obtain maximum depth of field at any given aperture—perfect for capturing plants in their natural environment, or for any situation where front-to-back sharpness is a priority.

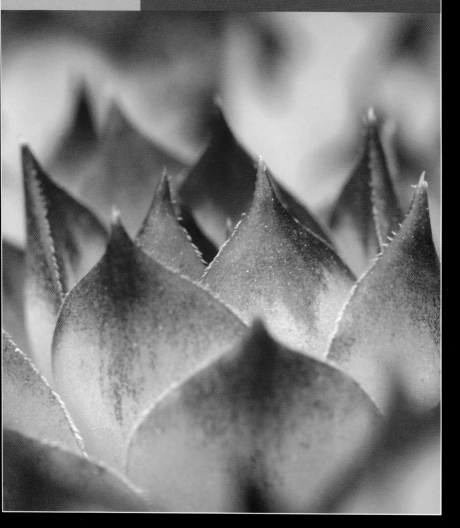

**Canon EOS 10D, 105mm lens,
1/60 sec. at f/9, ISO 400**

ATTRACTING ATTENTION
Focusing the lens on the center peaks of this garden succulent helps to
pull the viewer into the frame.

Differential/selective focus

On some occasions, extensive depth of field is simply not desired. Many plant photographers, for example, use wide apertures to throw foreground and background details out of focus, resulting in an abstract wash of color and shape. Pictures like these often contain a precise point of focus—the edge of a petal, top of a stamen, or underside of a sepal, for example.

Limiting sharpness in this very controlled way is called differential (or selective) focusing. When using this technique, it's a good idea to mount the camera on a tripod and, if possible, use a set of focusing rails *(see page 32)*. At large magnifications even minor adjustments can throw the focusing out, so make a point of checking the results regularly on your LCD monitor.

Working distance

Working distance is often confused with focusing distance, and the terms are sometimes used interchangeably. Working distance, however, refers to the space between the front surface of the lens, and the point on the subject where the lens is focused. Focusing distance, on the other hand, refers to the distance between the focal plane (the sensor/film) and the subject.

SHOOTING "THROUGH" FLOWERS
By switching the lens to manual focus I was able to shoot "through" the sea asters, concentrating on a single flower in the distance.

Canon EOS 10D, 105mm lens, 1/180 sec. at f/4.5, ISO 200

Using Autofocus (AF)

When the first mass-produced autofocus (AF) camera appeared in the late 1970s it featured a fixed-aperture lens, and three shutter speeds. Over three decades later, high-spec DSLRs feature numerous AF points, and can be teamed with countless lenses. All of these advances have benefited photographers, and the medium of photography in general. Autofocus, in particular, has changed the face of nature and sports photography, while transforming the field of photojournalism. While it certainly has its place in close-up photography, there are occasions when manual focus is preferable.

Focusing on off-center subjects

Many compositions are stronger when the main subject is positioned to one side of the frame—particularly when the arrangement adheres to the rule of thirds *(see page 112)*. Unfortunately, autofocus systems tend to prioritize the center of the frame, which dramatically limits creativity. This problem can be overcome by either "locking" the focus and recomposing the shot; selecting one of the camera's individual autofocus points, or switching the lens to manual focus. (The last of these three options is covered on *page 75*.)

Locking the focus usually involves placing the main subject in the center of the frame, pressing the shutter-release button halfway, and holding the button down while recomposing the shot to place the subject off-center—all the time the shutter-release button

OFF-CENTER SUBJECT
By selecting an individual AF point, I was able to focus on the head of this greater stitchwort.

Canon EOS 10D, 105mm lens, 1/750 sec. at f/3.5, ISO 400

is semi-depressed, the focus will be locked (which is why the technique is sometimes referred to as "focus lock"). When you are happy with the composition, you simply press the shutter-release button down fully.

Whether you can select an individual AF point will depend on the camera you're using—some high-end compacts offer the facility, but it's a feature most frequently found on DSLRs. The number and position of the AF points can range from one (in the center) to over 45 on pro-spec models. (At this point it's worth noting that the central AF point is always the most sensitive.) Having enabled the AF point selection facility, it's usually a simple case of toggling through the options until the desired point flashes in the viewfinder.

Note

Some cameras feature a third Autofocus mode, which switches between One Shot Autofocus and Continuous Autofocus if a still subject starts to move, or vice versa.

Autofocus modes

Most cameras feature at least two focusing modes: one shot and continuous.

One Shot Autofocus

One Shot Autofocus is suited to relatively still subjects. When you press the shutter-release button halfway, the camera will focus once on the subject. For as long as the shutter-release button is pressed, focus will be locked and you can recompose the picture. To refocus, you need to release the shutter-release button before depressing it again. Any AF point that achieves focus will usually flash briefly in the viewfinder, and you may also hear a beep sound. The exposure settings for the picture will normally be determined at the moment of focus.

Continuous Autofocus

Continuous Autofocus is suited to moving subjects. When you press the shutter-release button halfway, the camera will continue to readjust focus automatically as the subject moves. When the AF point selection is set to automatic, the camera will use the center AF point first to achieve focus. As a result, you must make sure that the subject is central in the frame to begin with. When the subject moves away from the center, the focus will continue to track it, as long as it is covered by another AF point. The exposure settings for the picture will normally be determined at the moment of focus.

Canon EOS 10D, 105mm lens, 1/90
sec. at f/4.5, ISO 200

FREEZING MOVEMENT
Continuous Autofocus is best suited to continually moving
subjects, such as flowers blowing in the wind.

When autofocus fails

While camera manufacturers often pride themselves on the speed and precision of their autofocus systems, there are plenty of occasions where manual focus (MF) has a role to play. Firstly, when using a reversing ring, the camera can experience a loss in automatic metering and focusing systems. As a result, manual focus is the only way to guarantee sharp results.

Secondly, if light levels are low, or the scene displays extremely low contrast, then the lens can struggle to "lock on" to the subject, causing it to zoom in and out as it struggles to focus.

Thirdly, backlit or reflective surfaces can also cause the autofocus system to fail. Finally, many cameras will try to focus on an area of high contrast first, while prioritizing the center autofocus point by default. Unfortunately, the

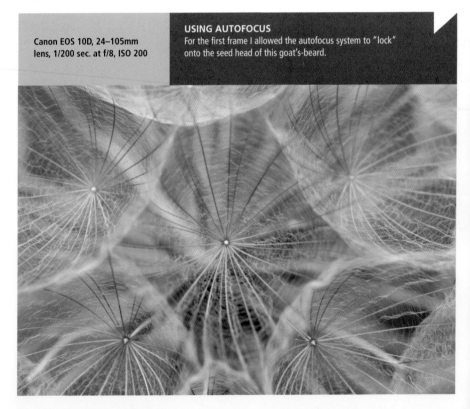

Canon EOS 10D, 24–105mm lens, 1/200 sec. at f/8, ISO 200

USING AUTOFOCUS
For the first frame I allowed the autofocus system to "lock" onto the seed head of this goat's-beard.

subject of the photograph does not always match the technical agenda of the camera. As a result, the photographer is forced to switch the lens to manual focus to ensure that the main subject is sharp.

Using manual focus (MF)

Many compact cameras feature a manual focus (MF) facility, although this can be tricky to use—photographers often need to zoom in to a section of the frame and then fine-tune the focus using a wheel. When using a bridge or DSLR camera, you can often use the autofocus system to "lock on" to an area close to your subject and then switch to manual focus (MF) to refine the result. If your DSLR has a Live View facility you can magnify the area where you want the focus to be, and turn the focusing ring until the subject appears sharp.

Canon EOS 10D, 24–105mm lens, 1/200 sec. at f/8, ISO 200

USING MANUAL FOCUS
For the second frame I switched the lens to manual focus and trained it on the center of the goat's-beard flower.

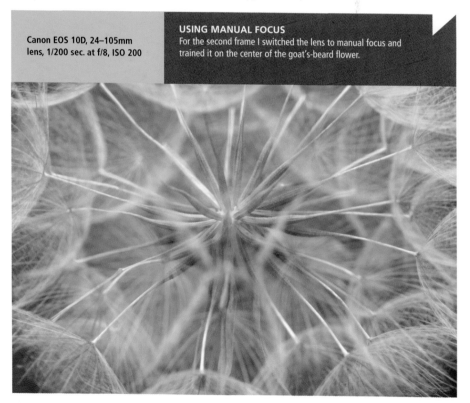

CHAPTER 5 UNDERSTANDING LIGHT

The vital element

No photograph can exist without light. Whether this illumination comes in the form of the midday sun or a flickering candle, the quality, direction, and temperature of this light can have a profound effect on how a subject appears, and how it is captured by the sensor or film.

Hard light creates dense, hard-edged shadows, while those that appear in soft light have a more gradual edge. The position of the light source also has a role to play. When low light hits a subject, long shadows are thrown across the frame, while texture and detail become more evident. By contrast, light from a source high above the subject (such as the sun) casts short shadows, and tends to flatten texture. Finally, while it might be invisible to the naked eye, light actually has a color temperature, which changes throughout the day. All of these properties help to determine how an object looks in the final photograph.

Light properties

Some newcomers to photography will find a suitable subject, and photograph it whether the conditions are favorable or not. However, the key to successful image making is to suit the subject to the light, or the light to the subject. If the only day you have free for photography is bright but overcast, try shooting a plant portrait—a thin layer of cloud is perfect for lowering contrast and reducing glare on foliage. On the other hand, if you have found a photogenic subject but the light isn't quite right, come back another time—you can always use a sun compass to help you previsualize the scene on a different day, or under different light conditions.

> ### Note
> *As we have seen, the amount of light that enters the camera and reaches the sensor is controlled by a combination of aperture and shutter speed. How sensitive the sensor/film is to light is determined by ISO (see Chapter 3).*
>
> *The amount of light being reflected from a subject is measured by metering systems built in to your camera—the most common types are Multi-zone, Center-weighted average and Spot metering (see Chapter 3).*

Canon EOS 10D, 150mm lens, 1/90 sec. at f/8, ISO 400

REDUCING CONTRAST
If the only day you have free for photography is bright but overcast, try shooting a plant portrait—a thin layer of cloud is perfect for lowering contrast and reducing glare on foliage.

Quality of light

While we all know that the sun rises in the east and sets in the west, few of us take the time to observe how the intensity and direction of this light changes throughout the day, or during different weather conditions. Failing to recognize these shifts prevents us from determining when a subject will appear in the most favorable light. While we can often modify the light with diffusers, reflectors and flashguns, we can reduce the need for these accessories by noting whether the light we have to start with is hard or soft, direct, or diffused.

You can predict where the sun will rise and set at different times of the year by using a sun compass. This unassuming device also enables you to determine how high the sun will rise at certain times of the year—information that can be used to check if the sun will "clear" a particular hill or building sufficiently to illuminate your subject—naturally the same information can be used to predict where the shadows will fall.

Hard and soft light

Light is generally considered to be either hard or soft. Hard light tends to come from a

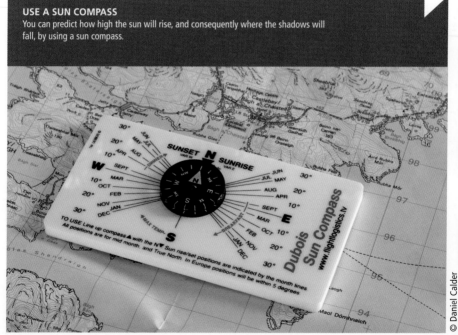

USE A SUN COMPASS
You can predict how high the sun will rise, and consequently where the shadows will fall, by using a sun compass.

© Daniel Calder

single source and a single direction (the sun, for instance). This type of light creates harsh, unforgiving shadows and high contrast. Soft light, on the other hand, often comes from multiple sources or multiple directions (e.g., the sun diffused by light cloud). This kind of light produces low contrast, and where shadows do appear they are generally softer.

It's important to be aware that when we describe light as being either hard or soft, this does not refer to how bright or dim the light is. In fact, the description actually has more to do with the shadows created by the light: hard light creates shadows displaying a "hard" edge (or abrupt transition between light and dark) whereas soft light creates shadows displaying a "soft" edge (or gradual transition between light and dark). As a result, a hard light can also be weak: think of a flashgun diffused by a plastic panel. A soft light can also be strong: think of a bare light bulb shining uninterrupted onto your subject. Both types of light have their uses in close-up photography: hard light can give an object a sense of depth and modelling, for example, whereas soft light can reveal detail in subjects such as leaves and petals.

Canon EOS 10D, 105mm lens, 1/90 sec. at f/5.6, ISO 200

REVEALING DETAIL
Soft light, such as that produced by diffused sunlight, is excellent for reducing contrast and revealing detail.

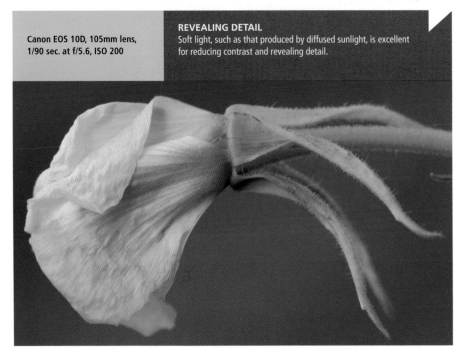

Time of day

The quality of (natural) light is largely determined by the time of day. In the hour or so before dawn, the light is soft, contrast is low, and shadows are weak or nonexistent. Just before the sun breaks the horizon, color begins to appear in the sky. As the sun steadily rises, the light grows warmer, and long shadows rake across the landscape, emphasizing texture and form.

By mid-morning the height of the sun is delivering intense light, decreasing the length of the shadows, leading to flat, featureless landscapes. Midday is perhaps the least conducive for photography: the sun is at its highest point, and colors will appear deeply saturated. This state of affairs will continue until well into the afternoon.

As the sun begins to descend, long shadows appear again, and the light regains its warmth. After the sun has disappeared below the horizon, a wash of color remains in the sky, and the light grows dimmer, but gentler still.

Canon EOS 10D, 24–70mm lens, 1/90 sec. at f/5.6, ISO 100

WARM LIGHT
By late afternoon, the sun is lower in the sky, illuminating objects with a warm, flattering light.

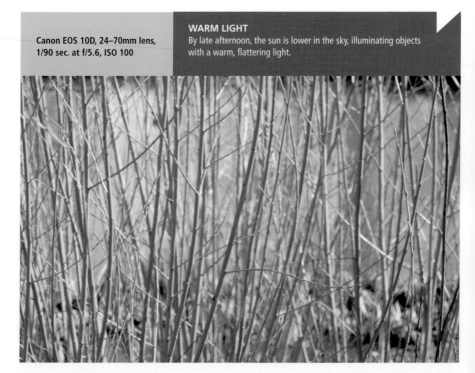

Contrast

Put simply, contrast is the difference between the lightest and darkest areas in a scene or photograph—otherwise known as highlights and shadows. When we study an object, our eyes automatically adjust to the vast range between the light and dark areas, allowing us to see detail in the blackest shadows and the brightest highlights. However, a digital sensor (or film) is only able to record a limited range of contrast.

When the difference is too great the sensor/film will record images that lack detail in either the darkest or brightest areas. To solve the problem, photographers usually make a choice between exposing for the highlights or exposing for the shadows. Which they decide to prioritize will depend on the subject. Thankfully, contrast is not a major problem for close-up photographers— since subjects are often quite small, the difference between light and dark areas can typically be controlled with the use of reflectors and diffusers.

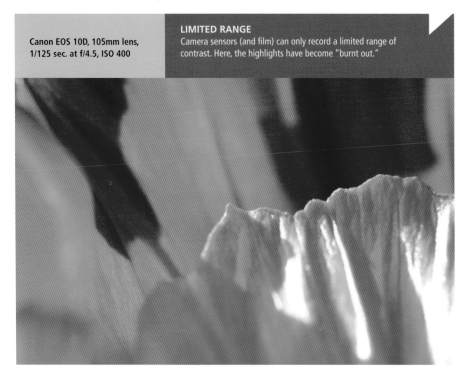

Canon EOS 10D, 105mm lens, 1/125 sec. at f/4.5, ISO 400

LIMITED RANGE
Camera sensors (and film) can only record a limited range of contrast. Here, the highlights have become "burnt out."

Direction of light

The direction of light has a crucial part to play in the making of a successful photograph. When a light source is positioned to one side of an object, for example, it can reveal surface texture, whereas an object lit from behind can appear either as a silhouette or a translucent object (depending on its opacity).

Perhaps the best way to study the effects of light is to take an object and place it on a table in a darkened room. Next, light the object with a single desk lamp: position the light to the side, front, back, top, and bottom of the subject. Observe the results, paying particular attention to where the shadows fall. These dark areas help to give an object a sense of three-dimensionality—something that product photographers often use to their advantage. Finally, position the lamp to the side of the subject again, but this time move it closer and then further away, noting how the intensity of the light changes. Repeat the process with the lamp positioned to the front, back, top, and bottom of the object.

Canon EOS 10D, 105mm lens, 1/80 sec. at f/4.5, ISO 400

LIGHT DIRECTION
When a light source is positioned behind a leaf it helps to highlight the intricate branch-like veins.

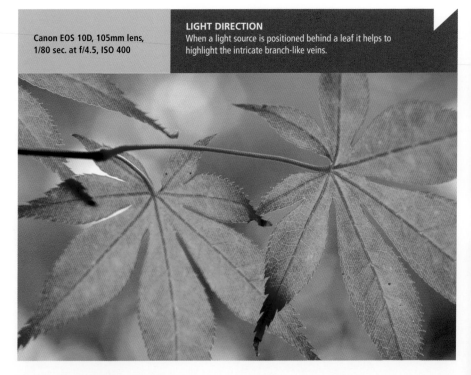

Top lighting

When an object is illuminated by light from
above, the resulting image can appear rather
flat and two-dimensional. Newcomers to
photography often rush out in the midday
sun and snap away in the hope of catching
bright, dramatic pictures. Sadly, for most types
of photography, top lighting is best avoided.
To minimize the effects, photographers often
use fill-flash to eliminate the shadows, or
reflectors to "bounce" light back in to the
effected areas. Sometimes top lighting is
unavoidable (e.g., when the clouds depart and
your subject is suddenly bathed in sunlight). In
these instances, you can employ a diffuser to
soften the light. On the plus side, top lighting
is sometimes used to accentuate colors, and is

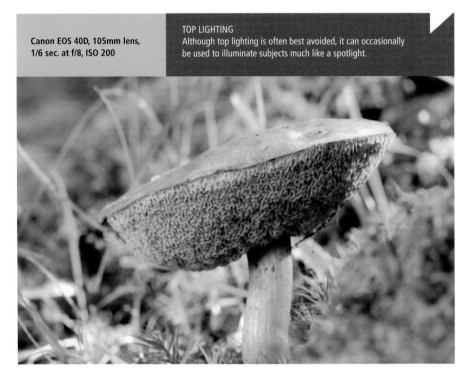

**Canon EOS 40D, 105mm lens,
1/6 sec. at f/8, ISO 200**

TOP LIGHTING
Although top lighting is often best avoided, it can occasionally
be used to illuminate subjects much like a spotlight.

popular with product photographers who team it with softboxes and other light sources to create artfully lit pack shots.

Front lighting

Front lighting, as its name suggests, occurs when the sun (or alternative light source) is illuminating the portion of the subject facing the camera. As with top lighting, this type of illumination can make the scene appear rather flat. At one time it was common practice to tell people to keep the sun behind them, but as the shadows fall behind

any elements in the frame, composing pictures in this way often leads to bland, lifeless scenes. On the plus side, front lighting helps to emphasize colors, and produces an even light that is easy to predict and manage.

Backlighting

When a light source is situated behind a subject (e.g., facing the camera) the object is described as being backlit. This form of illumination is often employed to create bold silhouettes, but it can also be used in

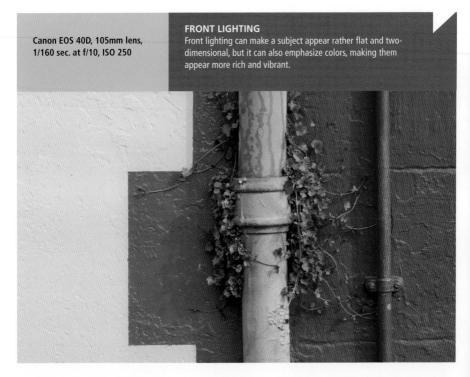

Canon EOS 40D, 105mm lens, 1/160 sec. at f/10, ISO 250

FRONT LIGHTING
Front lighting can make a subject appear rather flat and two-dimensional, but it can also emphasize colors, making them appear more rich and vibrant.

conjunction with translucent subjects to highlight their fragility.

When backlighting is used to create silhouettes, care must be taken over exposure. To reduce an object to a simple dark shape, devoid of all detail, take a spotmeter reading from a bright area of the background, and then bracket one or two-stops over the recommended exposure. (Be careful not to point your lens directly at the sun, as this can be dangerous.) When shooting towards the sun you'd be wise to fit a lens hood, or at the least shield your lens with a piece of card to prevent glare.

For a more subtle effect, you might like to consider rim lighting. This technique involves positioning a strong light source (such as the sun) behind a subject, and allowing it to block out most of the light, with a little "spilling" over the edges to create a bright outline. Rim lighting is ideal for drawing attention to hairy plant stems (such as those found on poppies) and is even more striking when the main subject appears against a dark background.

Canon EOS 40D, 10–20mm lens, 1/40 sec. at f/7, ISO 100

ROUND THE BACK
Backlighting can create bold silhouettes or highlight the fragility of translucent objects—occasionally it can do both.

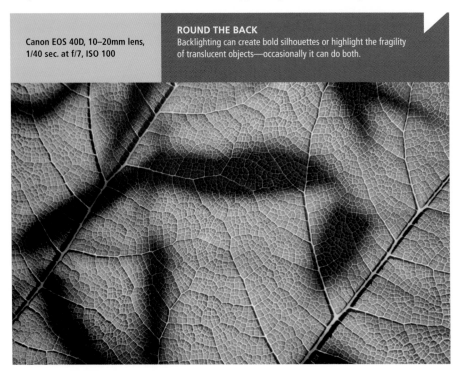

Side lighting

When an object is illuminated by a light source positioned to one side, long, dark shadows appear, emphasizing texture and form—as a result, the image has a distinctly three-dimensional feel. This type of lighting is most frequently observed when the sun is low in the sky (during early morning and evening). Landscape photographers often refer to this lighting as "golden" as it adds a welcome sense of depth to their vistas (as well as warmth and softness).

When using side lighting shadows become an important part of the composition—as a consequence their position must be considered carefully. If these dark areas become visually distracting, they can often be eliminated by using reflectors on the opposite side of the light source.

Base lighting

Lighting an object from underneath is a technique often used by product photographers to bring luminosity to glassware, acrylic objects, and jewelry. Base lighting is usually achieved using an illumination panel, which is positioned under a translucent object in a light tent. To complement the setup, a daylight-balanced lamp is used to one side of the tent, with another lamp at the back. (Care must be taken to ensure that all of the light sources are the same temperature, as mixed lighting is very hard to correct during post-production.) Daylight-balanced illumination panels can be expensive, but you can now pick up lightboxes used for viewing transparencies at a reasonable price secondhand—these may be thicker and heavier, but they will certainly do the job.

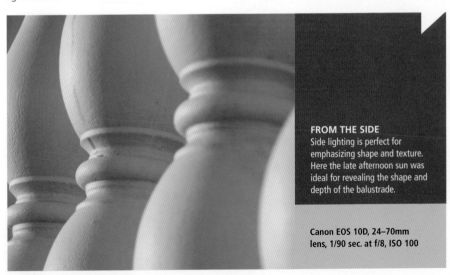

FROM THE SIDE
Side lighting is perfect for emphasizing shape and texture. Here the late afternoon sun was ideal for revealing the shape and depth of the balustrade.

Canon EOS 10D, 24–70mm lens, 1/90 sec. at f/8, ISO 100

Controlling light

Learning how to control and direct light is a skill that any photographer, regardless of their chosen genre, should strive to perfect. Light can reduce or enhance shadows, increase or reduce contrast, and hide or highlight detail. Whether you're using artificial light or natural light the strength and direction of this source can be altered or modified to suit your subject matter.

Using a diffuser

The main role of a diffuser is to soften the strength of the light and reduce areas of contrast in the scene. These accessories usually come in the form of a white (or neutral colored) piece of fabric stretched over a sprung circular frame. While they might seem basic in construction, these lightweight accessories are invaluable for shooting outdoors on a bright sunny day.

When the sun is high in the sky the light it casts is harsh and unforgiving, which creates unflattering conditions for close-up subjects. Thankfully, clouds make great natural diffusers as they scatter light, making it appear softer and more evenly distributed. Flower photographers, in particular, are aware of the way that clouds broaden and soften light, and will often wait for bright but overcast conditions before shooting plant portraits. However, when a thin layer of cloud is nowhere to be seen, similar effects can be achieved by casting a shadow over the subject with your camera bag, a piece of white material, or even your body. In the

SHINE SOME LIGHT
By placing this egg in a light tent, the illumination from two daylight-balanced bulbs (placed on either side) was diffused by the fabric of the tent.

Canon EOS 10D, 105mm lens, 1/125 sec. at f/5.6, ISO 100

studio, diffusion is most commonly achieved by bouncing artificial light off a broad surface (effectively spreading it over a larger area), using a plastic panel over the head of your flashgun, or employing a softbox or umbrella. Many accessories for diffusing (and reflecting) light can be purchased from Lastolite *(see page 189)*.

(see page 189)

Tip
You can make your own flash diffuser by securing tissue or tracing paper to the flash head with an elastic band.

Using a reflector
The main role of a reflector is to reduce or eliminate shadows by reflecting light in to dimly lit areas—the intensity of this "bounced" light can be adjusted by moving the reflector closer or farther away from the subject. Reflectors generally come in the form of a white, silver, or gold piece of fabric stretched over a sprung circular or triangular frame. While the white reflector has no effect on the color of the light, the silver cools it slightly, and the gold adds a touch of warmth. Plant photographers often use reflectors to bounce light into flowerheads or reveal detail in the gills of fungi. While the shop-brought versions are relatively inexpensive, you can make your own using a sheet of aluminum foil. Simply crumple up the foil, and roughly flatten it out again. Now, with the shiny side facing outwards, fold the foil over a piece of

stiff card. You can use this homemade reflector to bounce light into any problem shadow areas.

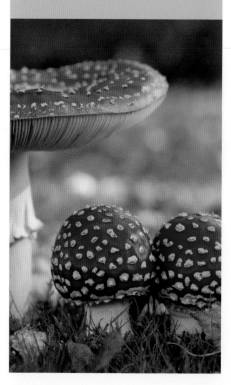

SHINE SOME LIGHT
Reflectors are great for shining light onto the gills of fungi—you can make your own using aluminum foil and a piece of card.

Canon EOS 40D, 105mm lens, 1/50 sec. at f/7, ISO 100

Understanding color temperature

In order to understand color temperature, we need to pay a visit to a blacksmith. When iron is heated in a forge it steadily begins to glow. By observing the change in color a blacksmith knows exactly when to remove the iron from the heat in order to bend, hammer, or cut it. The metal first glows red (which is why we often say something is "red hot"), it then glows orange, and after that it glows yellow. When the iron reaches yellow-orange, the blacksmith sets to work. If the iron is left in the furnace to get hotter, it will eventually turn white (which is why we use the term "white heat"), and then finally melt.

In 1848, the British physicist William Thomson devised a scale for determining the color of light given off by materials as they are heated—the Kelvin scale. On the Kelvin scale, colors that we consider cool—blue, green, etc—have a high color temperature, whereas colors that we think of as being hot—red, orange, etc—have a low color temperature. If we return to the furnace, then this topsy-turvy approach makes sense. When a fire is burning at a relatively low temperature, the flames are often red or yellow. When the fire becomes hotter, the flames become blue, or even white.

Canon EOS 40D, 10–20mm lens, 1/40 sec. at f/28, ISO 200

DUSK'S WARM LIGHTING
Occasionally the camera will try to "correct" the warm light experienced at the end of the day. To solve the problem, pair the lighting conditions with the appropriate White balance preset (see page 92).

Using white balance

Knowing the approximate color temperature of a light source is vital to photographers, as it helps them to avoid unnatural color casts. Incredibly, most of the time our eyes and brains make adjustments to correct these casts, whether they occur as a result of natural light or an artificial source. Consequently, when we look at a white object it appears white, regardless of the temperature of the light source illuminating it.

Unfortunately, a digital sensor has no way of making such a human assumption, and so it faithfully displays the temperature of the light, turning a white object blue, pink, green etc, depending on the source. In addition, color temperature alters throughout the day: light often appears bluer in the morning or evening, for example. To solve the problem, many cameras come with white balance presets. These presets range from Shade (7000–8000K) to White fluorescent light (4000K).

Most newcomers to photography will keep their camera set to AWB (Auto White Balance), which is fine in most situations. However, problems arise when the camera tries to "correct" intentional color casts such as the lovely warm light experienced at the end of the day during a sunset. As a result, it's a good idea to pair the lighting conditions with the appropriate preset. Having said that, it's important not to be too slavish when it comes to white balance presets: the tungsten setting, for example, can be great for adding a chill to ice and rocks. Don't be afraid to experiment. (If you don't want to commit yourself to a white balance setting at the time of the exposure, then shoot RAW and try out the options later using post-production software.)

Light source	Color temperature in Kelvins (K)
Clear blue sky	20000
Shade in summer	8000
Overcast sky	7000
Lightly overcast sky	6300
Electronic flash	6000
Summer sunlight	5600
Late afternoon/early morning sun	4500
Hour before dusk/dawn	3500
Tungsten floodlights	3000
60 watt bulb	2800

Tip

If color casts are experienced when using transparency film, then an external filter will be needed to neutralize the effect. Blue flowers, for instance, will often appear pink or violet—this can be corrected using a very pale blue color correction filter.

TURNING TUNGSTEN
This oxeye daisy was shot in the late afternoon,
but I preferred a "cooler" look, so I switched
white balance on my camera to tungsten.

Auto white balance (AWB) 3000–7000K

AUTO WHITE BALANCE
A human eye sees a white object as white, regardless of whether it is lit by an indoor bulb or the sun. Depending on the light conditions, a digital camera needs a little help to record whites as white. The effects of the most widely used white balance (WB) presets can be seen on the facing page. (The rock was actually shot in open shade).

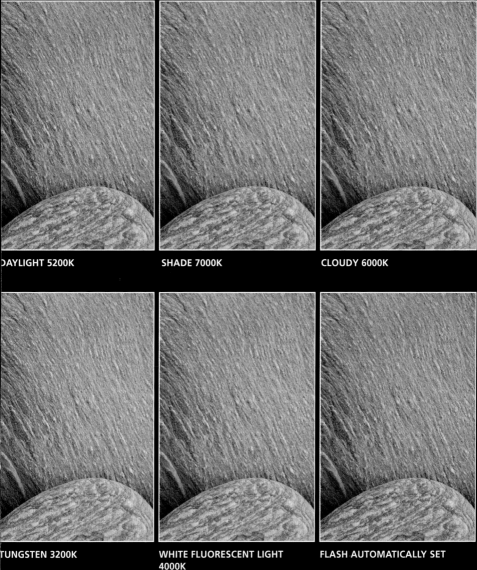

DAYLIGHT 5200K

SHADE 7000K

CLOUDY 6000K

TUNGSTEN 3200K

WHITE FLUORESCENT LIGHT
4000K

FLASH AUTOMATICALLY SET

CHAPTER 6 FLASH

Introduction to flash photography

Contrary to popular belief, flash photography is not a technique reserved for professional photographers. Furthermore, the tools required to master the process have never been easier to use. Whether you want to soften shadows, add catch lights to eyes, or bring out background detail, learning how to control artificial lighting will take your close-up photography to the next level.

Many DSLRs have two main features that make flash photography accessible to all: TTL (through-the-lens) flash exposure metering, and a large LCD monitor. The first of these properties lies at the heart of the camera. Both the ambient light and the brightness of the scene are measured during a burst of preflash. The camera then compares the results and determines the ideal exposure and flash output. Using TTL metering allows you to forget complicated exposure calculations, and leave the hard work to the camera. The second feature, a large LCD monitor, allows you to review images instantly, enabling lighting adjustments to be made within seconds.

Guide numbers

The power of a flash is expressed in meters and is known as its Guide Number (GN). This figure will determine the reach of the light (the higher the figure, the greater the coverage), and is governed by the sensitivity of the sensor. As a result, the GN is often accompanied by an ISO speed. Once you know the GN of a flash, you can use a calculation (GN/distance) to work out the ideal aperture for a subject at various distances. If, for example, the GN of your flash is 58 (at ISO 100) and your subject is situated 7 meters away from it, the ideal aperture would be f/8 (58/7=8.2). Similarly, the calculation can be adapted (GN/f-stop) to ascertain how far away your subject should be to enable a certain aperture. If, for example, the GN of your flash is 43 (at ISO 100) and you wish to use an aperture of f/18 you will need to position your subject 2 meters away from the flash (43/18=2.3).

Once you've familiarized yourself with the basics, flash photography has the potential to become so much more than just a light in the dark. Careful, considered use of flash can add depth or mood to an image, or even allow you to create multiple exposures. Furthermore, it doesn't have to be dark to call upon the services of this portable device: a burst of flash can be used to balance the light difference between a subject and its background in the middle of the day too.

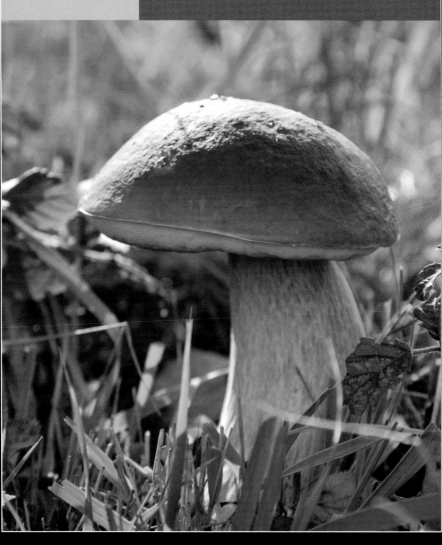

FILL-IN FLASH
A quick burst of flash can be used with daylight to fill-in shadows and reveal detail.

Canon EOS 40D, 24–105mm
lens, 1/30 sec. at f/7, ISO 100

Built-in flash

Many compacts, bridge cameras, and DSLRs feature a built-in flash, which can be used to complement ambient light. Unfortunately, the strength and reach of the artificial light is often incompatible with close-up photography. When using the pop-up flash on a DSLR, the subject often needs to be at least a three feet (a meter) away to prevent the lens from casting a shadow over crucial areas. (To try and solve the problem, some DSLRs now feature pop-up flashes that rise higher above the camera body—while this helps, it does not eliminate the effect.) It's best to avoid using the built-in flash for reproduction ratios beyond 1:2 (half life-size).

The light produced by the built-in flash tends to be harsh (although this can be adjusted using flash exposure compensation) and as the unit is fixed in position, the beam cannot be directed. While the strength of the pop-up flash can be softened using translucent material, such as tissue paper, such methods require you to increase the exposure to compensate for the reduction in light.

External flash

Most photographers begin their foray into flash with a single flashgun mounted on the hotshoe of the camera. These high-powered units offer bright illumination over a broad area, and are ideal for most "general" photography. They can often be tilted or swiveled to "bounce" light off of ceilings; or adjusted to strengthen or weaken the intensity of the light they deliver. However, when a flashgun is positioned above the camera, and the subject is close to the lens, it's difficult to angle the light onto the subject without the lens casting unsightly shadows.

To solve the problem, you can use off-camera flash and direct light exactly where you want it (including areas next to the lens). For close-up photography the ideal set up comprises two external flashguns positioned away from the camera (often on either side of the lens) using specially designed brackets. If you only have one flashgun, position it above the end of the lens, and angle the light so that it shines at 45° to the subject—at this angle the shadows will fall behind the subject, resulting in nice even lighting.

BUILT-IN FLASH
Some DSLRs now feature pop-up flashes that rise high above the camera body to reduce distracting shadows.

© Daniel Calder

Autofocus modes

Dedicated macro flash

There are two main types of macro flash on the market: ring flash and twin flash. These units can be used in conjunction with "non-macro" flashguns to achieve complex lighting set ups. If the macro flash is likely to create an underexposed background, for example, an additional flash unit can be used to brighten this area.

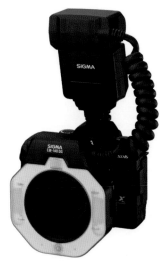

SIGMA EM-140 DG MACRO FLASH

Ring flash

Popular with medical and dentistry photographers, ring flash is also useful for general close-up photography as it provides even, shadowless lighting. These circular units are designed for short working distances, and are mounted on the lens rim, with the control unit slipping into the camera hotshoe.

On the downside, some ring flashes can produce rather flat lighting, which is why superior models, such as the Sigma EM-140 DG Macro Flash, feature two flash tubes that can be adjusted to vary the output. By altering the lighting ratio, you can deliberately create shadows, adding a sense of depth to a scene. Some models even allow you to rotate the ring flash around the lens to better position highlights and shadows. Ring flashes tend to have a relatively low GN (Guide Number) so you may need an additional flash unit to illuminate distant backgrounds.

Twin flash

Arguably the most popular lighting setup for close-up photography, twin flash units comprise two separate flash heads mounted on a ring around the lens, with the control unit slipping into the camera hotshoe. As with ring flash, the output between the two lights can be adjusted for precise control of the shadow areas. The heads can be fired together or separately. However, unlike ring flash, the heads can be moved, tilted, and sometimes even removed, for increased flexibility.

Top-end models, such as the Canon Macro Twin Lite MT-24EX, even feature focusing lights, which fire a preflash strobe to illuminate the subject and aid manual focusing. On the downside, twin flash is one of the more expensive options and, when fired together, the two heads can create double highlights, which can be distracting. Again, you may need an additional flash to illuminate distant backgrounds.

External flashguns for close-up photography

Flash units designed specifically for close-up photography offer unparalleled creative control over lighting. There are two main types: ring flash and twin flash.

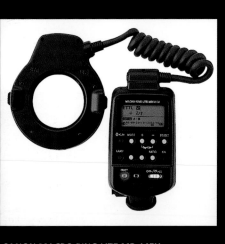

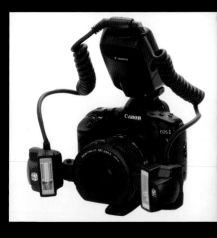

CANON MACRO RING LITE MR-14EX

Designed to create even, shadowless lighting for close-up subjects, the Canon Macro Ring Lite MR 14EX is compatible with all Canon EOS cameras. The unit consists of twin flash tubes, which can be fired together or independently. The ring can be rotated to light a subject from the side, above or below. The flash is activated via a control unit in the hotshoe (this can also be used to trigger remote EX-Series Speedlites).

Maximum Guide number (GN)
14 (meters at ISO 100)

Dimensions (w x h x d)
2.9 x 4.9 x 3.8in (74 x 125.9 x 97.4mm)—control unit

CANON MACRO TWIN LITE MT-24EX

Offering superior shadow control, the Macro Twin Lite MT-24EX features two fully adjustable flash heads and a separate controller unit that slides into the hotshoe. The twin heads can be rotated 80° around the lens, and even removed from the mounting ring for precise control. The flash is activated via a control unit in the hotshoe (this can also be used to trigger remote EX-Series Speedlites).

Maximum Guide number (GN)
124 (meters at ISO 100)

Dimensions (w x h x d)
2.9 x 4.9 x 3.8in (74 x 125.9 x 97.4mm)—control unit

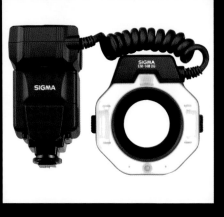

SIGMA EM-140 DG MACRO FLASH

Designed to work with DSLRs from all of the main camera manufacturers, the Sigma EM-140 DG Macro Flash features two flash tubes, which can be fired together or operated independently. When a single tube is fired, objects take on a three-dimensional feel. By contrast, when set to "shadowless" mode the flash produces even (deliberately flat) lighting.

Maximum Guide number (GN)
14 (meters at ISO 100)

Dimensions (w x h x d)
4.9 x 5.07 x 1.2in (126.6 x 128.8 x 30.5mm)—flash unit
3.01 x 5.3 x 3.2in (76.7 x 136.2 x 82.4mm)—controller

NIKON R1C1 WIRELESS CLOSE-UP SPEEDLIGHT SYSTEM

Intended as a complete close-up lighting kit for Nikon cameras, the Nikon R1C1 Wireless Close-up Speedlight System features two SB-R200 Speedlight flashguns and an SU-800 Wireless Speedlight Commander. The Speedlights can be tilted up to 60°, which is ideal for short working distances. The output ratio of each unit can be adjusted independently. Additional flashguns can be added to the master attachment ring to create a flexible lighting scheme.

Maximum Guide number (GN)
10 (meters at ISO 100)

Dimensions (w x h x d)
3.1 x 2.8 x 2.1in (80 x 75 x 55mm)—one SB-R200 flash unit

Full flash

Many close-up photographers avoid using flash because the effects can appear unnatural. When an object is close to the camera, flash may illuminate it beautifully, but throw the background (or anything beyond its reach) into darkness: butterflies, flowers, and fungi can look as though they were photographed in the middle of the night (a problem caused by flash fall-off, whereby the burst of light expands and reduces in intensity over distance).

In addition, full flash (where the flash is the main source of light) can strip an image of its atmosphere, and make outdoor subjects appear to have been shot in a studio. Despite these drawbacks, the benefits of using flash are hard to deny. When managed carefully, artificial light can produce natural results. Full flash is excellent for working at high magnifications (where slow shutter speeds would otherwise be required). Using full flash also enables smaller apertures (increasing depth of field).

Fill-flash

When flash is used to supplement ambient light, the technique is known as fill-flash. This effect can be used to soften shadows and reveal detail. The trick is to use enough light to "fill" the darkest areas without allowing it to flood the scene and become the predominant source. This balance is achieved by adjusting the power output of your external flashgun(s) to achieve the right lighting ratio.

By instructing the flash to fire at half its output, the balance between flash and daylight will be 1:2. Alternatively, use the flash exposure compensation feature and the built-in flash on your DSLR. In this instance -1-stop will be the same as half power, and -2-stops will be equivalent to quarter power. Many flashguns also offer automatic fill-in flash, where the unit works in conjunction with the camera to assess the scene and determine the output required. To make the most of these features, buy a flash that offers full integration with your camera.

© Brian Hallett

FINDING A BALANCE
Reducing the power output of your external flashgun removes shadows, while preventing the light source from flooding the scene.

Fuji FinePix S9500, 28–300mm lens, 1/90 sec. at f/8, ISO 200

Bounce flash

As the name suggests, bounce flash describes a technique whereby light is "bounced" off a wall, ceiling, or reflector. As the light hits one of these surfaces it spreads, thus reaching the subject as a softer, more flattering source. The strength of the illumination will depend on how far away the wall or ceiling is from your flash unit: the greater the distance, the softer the light. For the best results you need to use an external flashgun.

Many external devices can be tilted or swiveled, making them ideal tools for this technique. If the flash is mounted in the hotshoe, adjust the head so that it points up at the ceiling, wall, or other surface before it bounces back onto the subject. For greater precision, detach your flashgun from the camera and control it wirelessly—that way you can position it at the exact angle required, or bounce the light off a reflector back on to your subject. If the chosen "bounce" surface is colored, your light may take on a color cast—this can be used to your advantage to produce warmer or cooler tones (using a gold or silver reflector).

Diffusing flash

Another way to soften and spread the light of the flash is to use a diffuser—this will result in lighter and more natural-looking shadows, as well as lower contrast. A diffuser is a translucent material placed between the flash unit and the subject. Many flashguns have a diffuser panel built into the flash head, but you can create your own by securing tissue or tracing paper over the flash head. For a more permanent solution try a purpose-built diffuser.

Flash exposure compensation

Flash exposure compensation allows you to adjust the output of the flash, either via the camera or on the external flashgun. Put simply, positive compensation will increase the flash output, while negative compensation will decrease the flash output. By decreasing the flash output, you can reduce distracting highlights or reflections, but this may also underexpose your subject.

Flash exposure bracketing

Flash exposure bracketing (FEB) enables you to shoot a sequence of three shots with varying amounts of flash exposure compensation applied. The sequence is usually one standard exposure, one under and one over, but this order can often be altered. If you are using a flashgun that does not offer this facility you can manually apply flash exposure compensation to a series of three shots to achieve similar results.

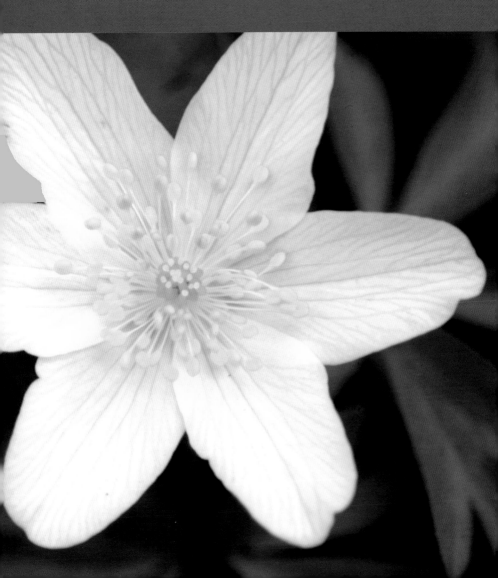

Introduction to composition

The way that elements are arranged in the frame can have a powerful emotional impact on the viewer. Learning how to balance light and shade with color, shape, and form, is crucial to a successful picture.

Learning the art of composition enables you to communicate your feelings about the scene or subject to a third party, strengthening the relationship between subject, photographer, and viewer. Successful photographs are a mixture of technical ability and creative input. While modern technology provides us with the tools to take sharper, punchier pictures, how we use those tools will depend on personal style and vision. Before we release the shutter we need to determine what attracted us to the subject in the first place; then, and only then, can we use technology to bring out those elements.

Creative eye

Developing a creative eye comes from studying the work of other artists, whether painters, photographers, or musicians. Each discipline requires precision, technical ability and, most of all passion. There is much to be learnt from observing the reaction we have to a piece of art or music, regardless of whether it is positive or negative. By understanding what pricks our emotions we can bring this knowledge to our own photography, helping us to develop a personal style.

CLOSER INSPECTION
Use a loupe to make a mental note of the patterns and textures of your chosen subject.

BALANCING ACT
Composing a successful picture involves balancing color, shape and form, as well as understanding light and shape.

Canon EOS 400D, 105mm lens, 1/1000 sec. at f/2.8, ISO 100

© Daniel Calder

Research

When it comes to close-up photography, learning about a subject can enable you to focus on areas of biological, scientific, or geological interest. When this knowledge is combined with technical expertise, the resulting photographs will have a strength and longevity that's hard to ignore.

Read the instructions

Spend some time reading your camera manual—taking control of the dials and buttons essentially means taking control of the picture making process.

Keep a scrapbook

Collect images, notes, illustrations, and diagrams that inspire you, and paste them into a scrapbook—when you're stuck for ideas, flip open the book and ask yourself what works, and why.

Use the Internet

When you've chosen a subject, look at how other artists handle similar ideas—don't just restrict yourself to photographers, study the work of painters, and writers too.

BECOME A BOOKWORM
Learn everything you can about your subjects by reading books and field guides.

Become a bookworm

Study field guides, geology books, maps, and magazines to learn everything you can about your subject.

Seek local knowledge

Ask rangers, wardens, or members of the public for advice on locations and/or unusual subjects.

Plan for the conditions

When you're photographing outside, it's important to check the weather forecast. If you're shooting flowers, make a note of the wind speed. If you're shooting rocks at the beach, write down the tide times. If warm side lighting is important to your shoot, check the

sunrise and sunset times. Finally, prepare a list of alternative subjects, just in case the weather turns bad—woodland, for example, often photographs well in drizzle or overcast conditions.

Once on location

Study your subject with a magnifying glass or loupe. Make a mental note of any patterns, textures, creases, or folds. Observe how the object changes under different light conditions.

Preshoot checklist

Whether you're planning a week "in the field" or an afternoon in a studio, using a preshoot checklist could save you time, and even money. Ideally you need to write your list at least 24 hours before the shoot; that way there is still be time to replace or repair essential items. While it might sound like extra work, compiling a list is a great way of clearing your mind, leaving you free to concentrate on taking photographs. Be sure to include the following:

• **Check batteries** The night before the shoot, check that your camera batteries, and those used in any external flashguns, are fully charged.

• **Clean equipment** Give your camera and lenses a thorough clean. Use a blower brush and cloth to remove dirt from the camera body, and a lens tissue and specialist solution to treat the lenses.

• **Scrutinize the sensor** Use a specialist loupe to check for loose dust particles on the digital sensor—dealing with these now could save you hours in front of the computer. Refer to

the manufacturer's instructions to clean the low-pass filter.

• **Check camera settings** Make sure that the main dials and menu items are set to default (or your preferred settings). Accidentally leaving your ISO set to 3200, or your camera set to Portrait mode could be fatal.

• **Write another list** Make a note of all the equipment you think you will need, and tape it to the inside of your camera bag. Tick the list as you place each item in the bag, and do the same when preparing to leave a shoot—that way nothing will get left behind.

• **Pack extra cards/film** Work out how many memory cards (or rolls of film) you need—then double this figure. It's a well known fact that you often run out of space/stock just as the perfect picture presents itself.

• **Set your alarm** If you're hoping to catch the predawn light, set an alarm clock. Similarly, if you want to take advantage of the warm evening light, set the alarm on your watch to give you plenty of time to get ready.

• **Think about food** If you're shooting outdoors pack a hot snack (a Thermos of soup is ideal) and plenty of water—remember to keep these separate from your camera equipment in case of any leakages.

• **Stay safe** Tell someone where you're going, and when you plan to return. Check the weather forecast one more time, and pack more clothing than you think you need.

Knowing the rules

Just like any other discipline, photography has its own set of rules. Many of these govern exposure, but some also influence composition. While these rules should not be followed slavishly, they provide useful guidelines for beginners.

The rule of thirds

The rule of thirds is a popular compositional technique used by painters, designers and photographers. The "rule" states that if you imagine the viewfinder divided into a grid using two horizontal and two vertical lines, you should place the key elements of your composition where these lines intersect. Some cameras even come with a grid function, which brings up a rule-of-thirds grid in the viewfinder.

Golden hours

Landscape photographers often describe the hours just after dawn and before dusk as the golden hours due to the warmth of the light, and the long raking shadows. The direction of light at this point is perfect for bringing out textures, and emphasizing form, as it creates deep shadows. Many experts suggest that this is the best time to head out with your camera.

KISS

Keep It Simple Stupid (or KISS) is a design principle that has enormous relevance for photographers. In short, it suggests that we avoid unnecessary complexity. Using the KISS principle we are encouraged to reduce the composition to its key components, thus strengthening the message we are trying to deliver to the viewer.

Lead-in lines

When we view an image we tend to "read" the information from left to right, or from the bottom to the top of the frame. In order to guide the viewer through the frame, you can use a device called a lead-in line. Commonly used in landscape photography, a lead-in line can be anything from a row of trees to an S-shape of ripples in the sand. Directing the viewer's eye in this way will ensure that the elements you have chosen are viewed in the order you intend.

Selecting a point of view

Even the most familiar subjects can be photographed in a new way if you spend a few minutes looking at them from every angle. Once the obvious is out of the way, you can experiment with unusual angles. Start by walking around the subject, perhaps kneeling down now and again and looking up at it to obtain a fresh perspective. If you can use a stepladder, wall or boulder to raise yourself above it, do so.

Canon EOS 10D, 105mm lens,
1/350 sec. at f/3.5, ISO 100

USING THE KISS TECHNIQUE
By reducing the composition to one or two key elements (in
this case shape and color) we deliver a clear, concise message.

Ask yourself what it is that you like, or even dislike about the subject. Is there a way that you can emphasize these characteristics? Perhaps you can move closer to isolate part of the subject from its background, or move further back to place the subject in the context of its surroundings.

Before you call it a day, make sure that you have recorded the subject using both portrait (vertical) and landscape (horizontal) formats. Once at home (or using the LCD on your DSLR while "in the field"), consider which orientation works best, and ask yourself why.

The psychology of lines

Lines can help us to direct the viewer around the picture frame, suggesting which areas of an image are more important, and proposing how we should feel about those areas once we arrive there.

Horizontal lines

More often than not, landscape photographs include a natural straight line: the horizon. When we see a horizon, we feel calm and grounded. While the majority of close-up photographs do not feature a horizon in the traditional sense, the frame can often still be divided into two unequal parts, instructing the viewer where to look first and how much importance to attribute to each area. By creating a "fake" horizon you are providing the viewer with a comfortable, familiar landscape, while encouraging the same sensations experienced when faced with the real thing.

Canon EOS 10D, 105mm, 1/90 sec. at f/3.5, ISO 100

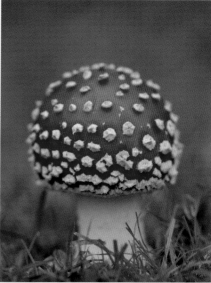

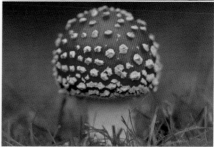

Vertical lines

We often associate vertical lines with growth and strength—e.g., flowers rise from the ground with tall, straight stems. When used in a photograph, these lines tend to direct the eye up through the frame at some speed, so it's important to include another element to help guide the attention back down into the frame.

Alternatively, the line can be interrupted by an object, highlighting its importance in the composition, and preventing the eye from racing out of the top of the frame. Vertical (and horizontal) lines can also be used to link elements of the composition together—these lines often take the form of edges between shapes or colors.

Curves

Many natural forms feature curves—think of the tight spiral of a snail shell, or the bumps and sweeps of the human body. These leisurely contours provide a sense of motion in a composition, as well as suggesting growth and health. In addition, curves can be used to provide three-dimensionality to a picture. By focusing on a small area of the curve, and allowing the rest to fall out of focus, the viewer gains a sense of depth by being pulled into the distance.

The psychology of shapes

Photographers often use points, lines, shapes, and patterns to create a sense of order in their compositions.

USING VERTICAL LINES
Vertical lines direct the viewer's eye up and out of the photograph. To prevent this from happening, you can interrupt the line with an object.

Canon EOS 10D, 105mm lens, 1/80 sec. at f/4.5, ISO 200

Triangles and hexagons

Geometric shapes lead our eye around the frame, creating links between elements, and divisions between colors. When a triangle appears in a composition it suggests strength and stability, a fact that increases when one of the three sides is formed by the bottom of the frame. However, when a triangle appears upside down in the picture, the mood is unsettling—once inverted, the shape suddenly seems unstable.

Anyone who has ever seen the inside of a beehive or studied the shell of a tortoise will appreciate the geometrical perfection of a hexagon. This six-sided polygon can be joined with other hexagons without leaving a gap—an arrangement known as tessellation. While such patterns satisfy our need for order, they can be rather monotonous to look at. As a result, photographers often introduce a small break, or visual pause, in the tessellation—a single cell of honey in a sea of empty honeycomb, for example.

Circles and spirals

The two most common shapes to be found in close-up photography are circles and spirals. These aesthetically pleasing forms add a sense of grace and movement to an image. While triangles and hexagons are best placed off-center in the composition, circles and spirals can be used dead center without disrupting the balance. Alternatively, a technique that has proved popular with food photographers is to cut a circle in half, positioning plates half in and half out of the frame. This device asks

the viewer to complete the circle, forcing him to take an active role in the making of the photograph.

PLAYING DOT-TO-DOT
You can position elements in the frame to create a shape in the viewer's mind—in this case a triangle.

Canon EOS 10D, 105mm lens, 1/60 sec. at f/4.5, ISO 100

Canon EOS 10D, 105mm
lens, 1/90 sec. at f/5.6,
ISO 400

DEAD CENTER
Circular objects can be placed in the center of the
composition without disrupting the balance of
the picture.

Rhythm and pattern

Rhythm is often used to describe the flow and repetition of elements within a photograph or painting. The human eye naturally follows similar shapes, lines, textures, and colors, especially if they recur regularly. Similarly, images featuring patterns appeal to our sense of order and balance, which is why we find them so pleasing to look at.

According to nature and environmental photographer Gary Braash, there are two types of pattern: positional and inherent. Positional patterns depend on the photographer's viewpoint, whereas inherent patterns occur naturally.

The most effective rhythms and patterns are often interrupted at a single point: a sheet of bubble wrap punctuated by one popped cell, for example. Perfect arrangements can sometimes make an image appear two-dimensional and boring, so it's important to add a note of variation.

Symmetry and reflections

When symmetry is used in a composition, the result can be beautiful, restful, or actually rather dull. As everything in the frame appears to have equal weight, the eye struggles to decide what to focus on first. Once this decision has been made, there is no natural path for the eye to take through the picture. As a result, the image can appear flat and lifeless. To alleviate this feeling, photographers often introduce an asymmetrical element into an otherwise symmetrical composition.

Reflections can be seen in countless surfaces

such as water, glass, and metal. These images are often arranged symmetrically. On these occasions, the viewer may gain a certain amount of satisfaction from guessing which way is up, or rotating the image to see how perfect the reflection is compared to the reality. On the other hand he/she may become frustrated by the same ambiguity. The photographer must anticipate both reactions.

EMBRACE DISORDER
Perfect symmetry can be rather dull to look at, so break the monotony with a few asymmetrical elements, like an off-center stem.

Canon EOS 10D, 105mm lens, 1/25 sec. at f/11, ISO 200

INHERENT PATTERN
According to photographer Gary Braash, some natural patterns, such as those created by a spider's web, are inherent.

Canon EOS 10D, 105mm lens, 1/90 sec. at f/4.5, ISO 400

OVERCAST LIGHTING
Some textures, such as wood grain, can be photographed in overcast conditions, but most benefit from the directional light experienced during the Golden Hours.

Canon EOS 40D, 105mm lens, 1/60 sec. at f/11, ISO 250

Texture

When we photograph an object we often move closer to study its lines, patterns and color; we hold it to the light to reveal its translucency, or pick it up to assess its weight. When we have explored the object fully, we have the unenviable task of trying to communicate what we have learnt to the viewer. While the sound, taste, and smell of an object is tricky to convey, how the object feels to the touch is easier to illustrate. By recording the texture of the object, the photographer asks the viewer to draw on his experience of similar surfaces.

In order to engage the viewer in this way, we need to use light to bring out the texture of the object. While some surfaces are best photographed in soft light, such as that created by a cloud blocking the sun (e.g., lichen on a rock) most benefit from a touch of side lighting. When the sun is close to the horizon (at either end of the day) the long shadows throw the surface into relief, revealing distinct layers and giving them the appearance of lifting off or peeling away—think bark, paintwork etc. This type of lighting can be recreated at home using daylight, a lamp or off-camera flash.

Canon EOS 10D, 105mm lens, 1/60 sec. at f/5.6, ISO 200

SOFT TOUCH
By recording the texture of the object, the photographer asks the viewer to draw on his experience of similar surfaces to (mentally) reach out and touch it.

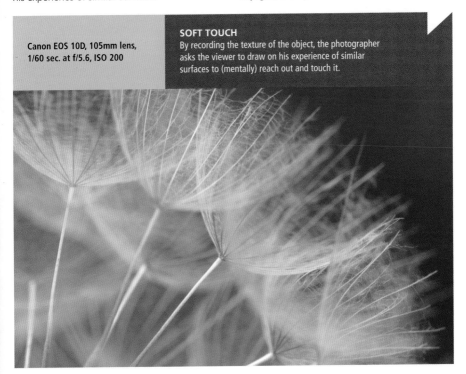

Scale

More often than not, close-up images lack the standard reference points we use to make judgements about size. When shooting a crack in a rock, for example, the photographer might fill the frame with the subject, eliminating any clues as to the surrounding environment. As a result, the crack could be the size of a pencil, or the size of the Grand Canyon. From the viewer's perspective, this type of ambiguity can be refreshing or frustrating in equal measure.

Shadows

Shadows direct the viewer's eye, create a point of interest in patterns, give shapes a three-dimensional appearance, and can even become the subject of an image themselves. As a result, when we previsualize how light will effect an object or scene at different times of the day or year, we must give equal consideration to how shadows will alter the mood and atmosphere of the final result.

Directing the eye

Shadows, by their very nature, contain far less detail than lighter areas, and are ideal for directing the viewer's eye around the frame. By underexposing the scene by one stop, any remaining detail in the shadows will be removed, reducing the chances of the eye becoming distracted. This is a great way of hiding any unwanted intrusions. In addition, these darker areas can be used to channel the gaze, creating a path through the picture. By casting certain areas into darkness, the

ENGAGING THE VIEWER
By eliminating reference points such as the sky from the frame, you can ask the viewer to decide whether the subject is tiny or huge.

Canon EOS 40D, 10–20mm lens, 1/20 sec. at f/9, ISO 320

photographer is also suggesting that these areas are less important than the lighter zones.

Creating contrast

In black & white photography, contrast refers to the difference between white, gray, and

Canon EOS 40D,
10–20mm lens, 1/125
sec. at f/16, ISO 100

REVEALING TEXTURE
In the late afternoon or early morning light, shadows
help to reveal texture in surfaces such as sand, bark and
paintwork.

black tones. This difference can be normal, high or low. When a scene is described as "high contrast" it often contains areas of pure black and white, with few gray tones in between. When a scene is described as "low contrast" it may contain similar tones of black, white, or gray, with no areas of pure black or pure white.

High contrast scenes suggest strength and power, whereas low contrast scenes are often softer and more forgiving. In color photography the richest blacks are usually found in the shadow areas, and the brightest whites in the highlights. Reducing a scene to these two extremes makes a powerful statement.

Bringing out texture

During the early hours of the morning and evening the sun is close to the horizon, creating long, rich shadows. Close-up photographers can use this light to enhance detail and reveal texture. If you're shooting inside you can create similar effects using light from a side window, or a carefully positioned lamp.

Positive and negative space

Generally speaking, the area of the frame containing the main subject is described as "positive" space, whereas the area surrounding the main subject is referred to as "negative" space. Finding a good balance between these two areas is a skill that requires practice. When you come across a photograph that appeals to you, ask yourself how the positive and negative areas relate to one another, and how the composition achieves balance.

When the frame contains too much negative space the subject can become overwhelmed and lose its dominance. By contrast, when a composition contains too much positive space, the subject can appear confined and compressed. Close-up photographers often use negative space to suggest growth—for instance, by leaving empty space above a flower the viewer is encouraged to think of the plant growing up and into this area.

Tip

Capturing a three-dimensional object or scene using a two-dimensional medium (photography) is always problematic. When an image appears as a final print it lacks the sounds, smells, and sensations the photographer experienced at the time of making the exposure—as a result, he/she must work hard to convey the richness of the scene to the viewer.

Canon EOS 10D,
105mm lens, 1/750 sec.
at f/5.6, ISO 400

USING NEGATIVE SPACE
By leaving negative space above a plant, the viewer is
encouraged to imagine it growing into the empty area.

Foreground and background

In order to give a photograph a sense of depth, it's helpful to consider it as having three distinct layers: foreground, middle ground, and background. Ideally, each of these layers will include an object, color, or other element that relates to the main subject of the photograph.

An image of a leaf, for example, might feature a wash of out of focus leaves in the foreground, and the branches that support the foliage in the background. For this technique to work effectively, all of these elements must relate to one another in some way.

Close-up photographers rely on the strength of an uncluttered background. Shooting objects at close range means that every line, color, or texture lurking behind the main subject has the potential to distract the viewer. To counteract this problem, you can fill the frame with the subject, while employing a wide aperture to throw the background, and often the foreground, out of focus. Alternatively, if the background or foreground provides useful information about the subject, you can use a small aperture to retain some of the detail.

Selecting a background

Finding a background that complements your subject, and strengthens the message of your photograph, is easier said than done. Some butterflies, for example, like to sunbathe on unattractive tarmac roads. If you're unable to relocate the subject to a more suitable backdrop, try using a wide aperture to throw the background out of focus—the greater the distance between the subject and the background, the less distracting it will be.

If you're able to move your subject, look around for a backdrop that adds to the story—a shell, for example could be placed on a layer of sand.

At times it's simply not possible to find a suitable background in the field. On these occasions, close-up photographers often decide to use an artificial backdrop. One option involves taking an out-of-focus photograph of some foliage, and printing it out. This fake backdrop is then positioned behind the subject to block out the real background. If you do decide to use a painted or photographed backdrop, remember to use three or four different versions to stop all your images from looking the same.

Finally, if a natural background fails to materialize, try to remain open to opportunities and use whatever is available to you. In the past I have used a barbecue cover, a beach ball, and even a muddy pond to provide a backdrop for plant portraits.

Canon EOS 40D,
105mm lens, 1/50 sec.
at f/6.3, ISO 200

USE THE BACKGROUND
The branches that support the foliage may be out of focus,
but they support the main subject—quite literally!

Canon EOS 40D, 105mm lens, 1/50 sec. at f/5, ISO 100

BLACK BACKGROUND
Dark backdrops work well with bright subjects—this plant was shot in the garden against the cover of our barbecue.

Canon EOS 10D,
105mm lens, 1/60 sec.
at f/3.5, ISO 400

PAPER BACKGROUNDS
These alliums were shot against a blue piece of paper—the
uniformity of the color has made the image a little flat.

Negative space

Having studied this tulip for some time, I decided to fill the negative space with a wash of purple, created by some nearby hyacinths. I used a relatively wide aperture (f/6.4) to render the hyacinths out of focus and prevent them from dominating the frame. As a result, the main subject (the tulip) remains the center of attention.

Camera: Canon EOS 40D
Lens: Canon 300mm
Shutter speed: 1/500 sec.
Aperture: f/6.4
Sensitivity: ISO 320

Blurring the background

Red is as much the subject of this image as the foliage itself, placing the shot firmly in fall. Having decided to focus on a small group of leaves, I selected a wide aperture (f/2.8) to allow the canopy to fall out of focus. The shutter speed (1/500 sec.) was ideal for freezing any movement caused by the wind.

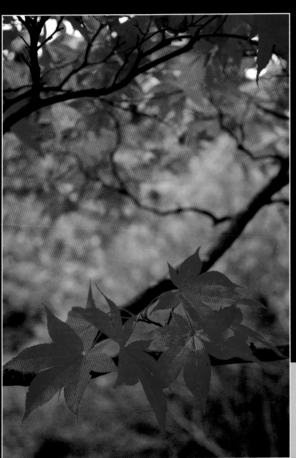

Camera: Pentax K200D
Lens: 35mm
Shutter speed: 1/500 sec.
Aperture: f/2.8
Sensitivity: ISO 200

Revealing details

Having selected a bright but overcast day I was able to use the diffused light to reveal the scratches and scars of this palm tree trunk. Thanks to the reduction in contrast, the camera recorded detail in both the shadows and highlights.

Camera: Canon EOS 40D
Lens: 105mm
Shutter speed: 1/30 sec.
Aperture: f/8
Sensitivity: ISO 200

By positioning the camera directly above the apples, the shapes, textures, and colors form pleasing patterns. After taking in the image as a whole, the eye is drawn to the markings and bruises of individual fruits. I positioned a single dark apple in the corner of the frame as a visual anchor.

Camera: Canon EOS 40D
Lens: 105mm
Shutter speed: 1/100 sec.
Aperture: f/6.4
Sensitivity: ISO 320

Creating an abstract image containing just shape and color was easy using differential focus. Having selected Aperture priority on my DSLR, I chose a wide aperture of f/2.8 and switched the lens to Manual focus (MF) to prevent it from "hunting" while trying to lock on to the subject.

Camera: Canon EOS 40D
Lens: 105mm
Shutter speed: 1/200 sec.
Aperture: f/2.8
Sensitivity: ISO 320

Using research

Bristly oxtongue *(Picris echioides)* grows in dry grassland and on disturbed ground. The flowers bloom between June and October. Using this knowledge, gleaned from various field guides, I located a suitable specimen, and timed my visit to coincide with the flowers dying off.

Camera: Canon EOS 40D
Lens: 105mm
Shutter speed: 1/200 sec.
Aperture: f/2.8
Sensitivity: ISO 320

Introduction to color

When we describe a tomato as red, what we are actually describing is the light reflected or absorbed by the tomato. The color is not an intrinsic property of the object itself. Understanding the basic rules of color will enable you to create better photographs.

In 1704 physicist Sir Isaac Newton (1643–1727) published a series of experiments proving that white light could be refracted via a prism to create the colors red, orange, yellow, green, blue, and violet. In addition, his findings confirmed that the colors could be mixed back together to create white light. While conducting his experiments, Newton also noted that objects appear colored due to the way that they reflect or absorb light.

These experiments helped Newton to understand the physics of light. He soon discovered that each color leaving the prism had a different wavelength, which could not be further divided. The human eye is sensitive to wavelengths between 400 to 700nm (nanometers)—a range otherwise known as visible light. While the eye registers the effects of light, the brain translates this information into what we understand to be color.

Adding impact with color
Using color to add impact to our photographs is not as complicated as it might sound—most of the time we arrange hues, tints, and shades in aesthetically pleasing ways simply by instinct.

However, by understanding the basic rules of color theory we can remove the guesswork, creating color combinations that convey our personal style, while communicating our feelings about the subject.

Psychological effects of color
The psychological effects of color can vary between cultures: black suggests death in western civilization, for example, whereas white is the "color" of mourning in China. Despite these variables, some responses are universal: blue and green, for example, are considered cool colors, promoting a sense of tranquillity and peace; whereas red and yellow are thought to be warm colors, linked intrinsically to danger and excitement.

Color can stimulate the senses, triggering the smell of freshly cut grass, or the sound of a police siren. It can make us feel happy or sad, energized or tired. It can awaken happy memories, or cause us pain and anguish. By studying the way that certain colors relate to each other, and the physical and emotional responses they evoke in us, we can begin to see how color effects both the mind and the body.

Canon EOS 10D, 105mm lens,
1/90 sec. at f/6.7, ISO 100

THE SCENT OF LAVENDER
This image features a plant that we know to be lavender—this
knowledge, and the unmistakable color, help us to conjure up the scent.

Red

Red is often associated with danger, heat, excitement, and a sense of urgency. It's an aggressive color, and tends to dominate an image, even in small quantities. The painter Henri Matisse once commented *"A thimble of red is redder than a bucketful."* Red instantly attracts the eye, reducing all other colors to supporting roles.

Yellow

Yellow is a positive color associated with warmth, activity, and the restorative rays of the sun. However, yellow has also been known to provoke feelings of frustration, and also to increase metabolism. When used as a pure hue, yellow can make a bold statement, but care should be taken not to overuse it, as it can cause weariness in the viewer.

Blue

Blue promotes feelings of peace, solitude, spirituality, and sometimes sadness. It's a cool color, and appears to recede in the frame, making it an ideal background hue. Blue is also thought to slow down the metabolism, and lower the pulse rate.

ATTRACTS THE EYE
While it might take up less than half the frame, the red of these berries dominates the composition.

Canon EOS 10D, 105mm lens, 1/80 sec. at f/4.5, ISO 200

Green

Green is the color of health, hope, and new life. It inspires feelings of peace, relaxation, and safety, as well as encouraging a sense of harmony. However, green should not be used on its own, as too much can cause fatigue in the viewer.

Orange

Orange is associated with energy, happiness, and warmth. As a combination of red and yellow, orange also inherits exciting and restorative properties. While not as attention seeking as red or black, it still has the ability to draw the eye, hence its use in traffic lights.

Black

In the West, black is used to signify death and unhappiness. However, in certain countries (e.g., Egypt) it actually symbolizes rebirth. While not strictly a color (it absorbs all light) black can play an important part in a composition, accentuating colors and shapes.

White

White is not strictly a color (it reflects all light) but when used sparingly it can have a dramatic impact on the viewer. White suggests space, and is often associated with purity, sterility, and innocence.

TOO MUCH OF A GOOD THING
Using too much green can lead to flat, uninteresting pictures. The shapes of the ferns here help to add a point of interest.

Canon EOS 10D, 105mm lens, 1/60 sec. at f/5.6, ISO 100

The color wheel

Having proven that color is a property of light and not, in fact, a physical property of an object, Sir Isaac Newton went on to display his core colors in the form of a wheel (or circle).

How much of the wheel was apportioned to each color depended on its wavelength and its width in the color spectrum. With the help of this device, Newton was able to prove that relationships exist between certain colors in the visible spectrum.

Over the next three centuries, scientists, painters, and philosophers all adopted the color wheel, altering its design, and even its shape, to suit their purposes. The most popular version (still used by artists today) contains three primary colors: red, yellow, and blue. These colors cannot be created by mixing others on the wheel together, and are placed equidistant from each another.

Primary colors are the building blocks for every other color—e.g., mixing blue and red results in violet, while a combination of red and yellow creates orange. By mixing two primary colors together in equal amounts you will produce one of three secondary colors: orange, violet, or green. These colors are positioned between each pair of primary colors on the wheel. The final gaps are filled by tertiary colors: red-violet, blue-green, yellow-orange, blue-violet, and yellow-green. These colors are created by mixing two secondary colors together in equal amounts, and take up the spaces between the primary and secondary colors.

PRIMARY COLORS

SECONDARY COLORS

TERTIARY COLORS

The color wheel

The primary, secondary, and tertiary colors of the color wheel make clear the relationship between each one, and how each is formed by mixing with its neighbor.

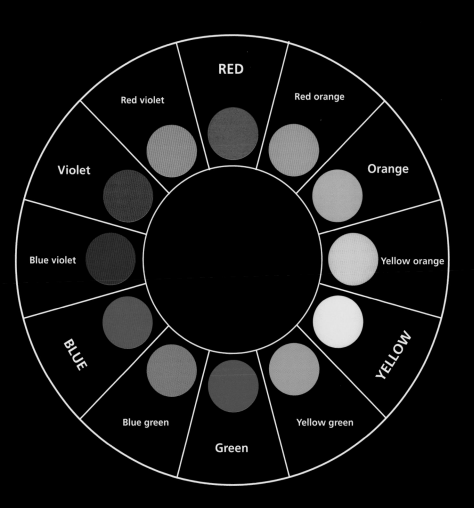

Hue, saturation, and value

Terms such as hue, tint, shade, saturation, and value are often used interchangeably when discussing color, but they actually describe quite different attributes.

Hue

The word hue is used to describe a pure color that has no white or black, and is the dominant wavelength of a light source. Blue, for example, is a pure hue, whereas purple is not—it simply contains the hue blue. By combining two or three pure hues in a composition we can create eyecatching images—think stars and stripes!

Saturation and value

The intensity (or saturation) of a color depends on how much white, black, or gray has been mixed with the original hue. Pure colors often have a higher intensity, and consequently a greater presence within the frame, than those that have been lightened or darkened. However, there are exceptions and some pure hues have less visual weight than others: red, for example, dominates a composition much

more than yellow, even if both are used in their purest form.

When a hue is mixed with white it is known as a tint; when it is mixed with black it is known as a shade, and when it is mixed with gray it is known as a tone—the resulting lightness or darkness of the color is known as its value. An image containing mostly high value colors (such as pastels) is known as high key since it contains more white, whereas an image containing mostly low value colors (such as dark red) is described as low key as it contains more black.

When a color has a low saturation (or intensity) it appears to recede in the frame, and is known as "passive." When a color has a high saturation (or intensity) it appears to advance in the frame and is known as "active." As a result, we can use passive and active colors together to create a sense of three-dimensionality in our photographs.

Color harmony

Colors that sit next to each other on the artist's wheel are considered harmonious. The contrast between these colors is at an all time low, as each color (whether secondary or tertiary) has been created by mixing the two colors adjacent to it. Restricting your color palette to neighboring colors can create balanced and harmonious images, which in turn are pleasant and relaxing to look at.

As ever, it's important to consider the balance of your composition when using harmonious colors—if the colors differ

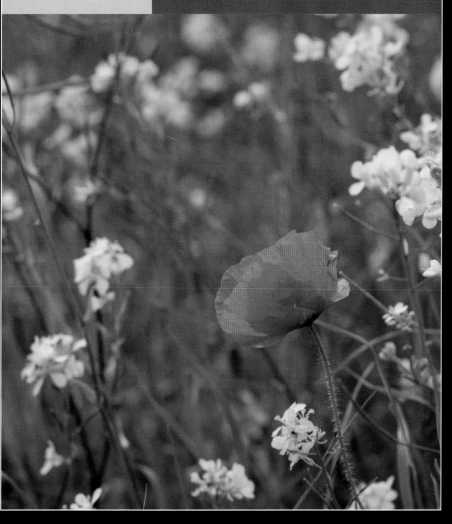

Canon EOS 40D, 105mm lens,
1/200 sec. at f/5.6, ISO 100

PURE HUE
Red dominates a composition much more than yellow, even if
both are used in their purest form.

dramatically in intensity (or saturation) they may begin to compete with each other. If possible, allow one color to dominate (perhaps one of the primaries) while the others provide visual highlights, or secondary interest.

Complementary colors

In the mid-nineteenth century French chemist Michel Eugène Chevreul publicized a detailed account describing how colors relate to one another, based on their position on the artist's wheel. Crucially, he noted that neighboring colors create harmony, whereas distant colors create contrast. The greatest color contrast lies in colors directly opposite one another on the wheel: yellow and violet, or orange and blue, for example. These are called complementary colors.

By limiting the number of complementary colors you use in your composition, you can greatly increase its visual impact. Using just two colors will make the strongest statement but, of course, they do not have to be of equal amounts—even the smallest red rose will stand out against a vast backdrop of green leaves.

COMPLEMENTARY COLORS

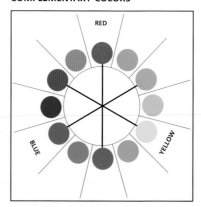

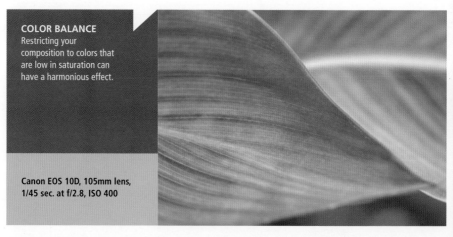

COLOR BALANCE
Restricting your composition to colors that are low in saturation can have a harmonious effect.

Canon EOS 10D, 105mm lens, 1/45 sec. at f/2.8, ISO 400

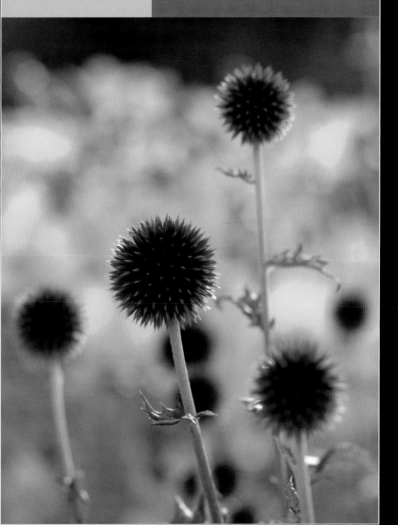

Canon EOS 10D, 105mm lens,
1/250 sec. at f/4.5, ISO 200

COMPLEMENTARY COLORS
Yellow and violet are situated opposite each other on
the color wheel, and create strong contrast.

CHAPTER 9 PROJECT IDEAS

Setting yourself a project

Shooting to a set theme gives purpose to your photography and allows you to explore a subject in-depth. By creating a coherent body of work you are honing your individual style as a photographer. Whether or not you complete the project is of little consequence; what's important is the level of passion and dedication you bring to the enterprise.

Canon EOS 40D, 105mm lens, 1/640 sec. at f/3.5, ISO 100

GET TO KNOW YOUR SUBJECT
Wood anemones close when light levels drop, so it's important to choose a bright, still day to catch them at their best.

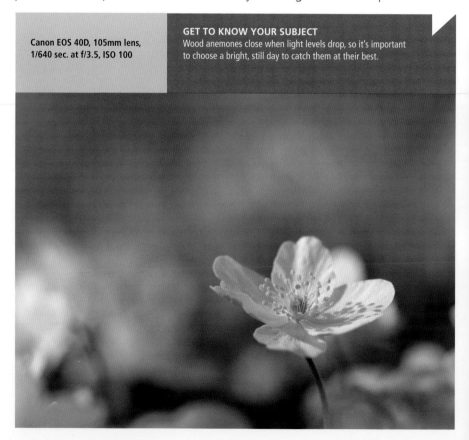

Project 1: Wildflower portraits

Britain's wildflowers are often underrated: daisies are yanked out of lawns, while nettles and thistles are cut down and discarded as weeds. Thankfully, close-up photographers see the world rather differently—the underside of a nettle becomes a place to discover butterfly eggs, while the white petals of a daisy display a pink flush that goes unnoticed to all but the keenest eye. In a bid to share the wonder of Britain's "weeds," I decided to shoot all of the wild flower species in the southeast county of Sussex.

Seasonal approach

Before starting the project I carried out a considerable amount of research. By studying field guides I was able to identify the key months when individual species would be in bloom, resulting in a diary of what to shoot when. To find suitable locations I enlisted the help of local reserve managers and online forums. After that it was simply a case of checking the weather forecast and hoping for a bright but overcast day to reduce the chances of blown out highlights.

While checking the weather forecast I also made a mental note of the wind speed— anything above 5mph (8kph) and my subject would be lurching across the frame, falling in and out of focus in the process. To reduce movement I fashioned a piece of cardboard into a windbreak, but my secret weapon was an invaluable accessory known as the Wimberley Plamp *(see page 38)*.

Close examination

On site, I used a loupe to examine stems and sepals—on occasion this was the only thing that differentiated one species from another. With a flower identified, I set about capturing its individual character. As with any subject, it's important to establish what attracts you to one specimen over another. If, for example, a petal is unusually translucent, you might use backlighting to reveal the venation. Similarly, if the surrounding vegetation is crucial to your plant, you could use a narrow aperture to record the habitat in sharp detail—this type of record shot is popular with botanists. For this project I decided to shoot plant portraits, with only a hint of habitat, so I used relatively wide apertures throughout.

Even when working with shallow depth of field, it's important to consider backgrounds. Having explored a plant from every angle, I would advise using a garden kneeling mat (being careful not to squash neighboring flowers) to sit in comfort while you study every corner of the frame, searching for distracting colors or stray vegetation. Even the smallest twig will appear branchlike when shot with a macro lens. The background should complement your subject, not compete with it. If possible, use the depth-of-field-preview button to check how much of the scene will appear in focus, before releasing the shutter-release button. If you decide to remove a leaf, or bend a stem to improve your background, always remember that many wildflowers are protected by law and should be left exactly as you find them.

Canon EOS 10D,
105mm lens, 1/90 sec.
at f/5.6, ISO 200

CHOOSE A SPECIMEN

Dying flowers can be equally as beautiful as those in their prime. This common poppy was twisting and curling as it decayed.

Canon EOS 10D, 105mm lens, 1/125 sec. at f/4, ISO 400

CONTROL DEPTH OF FIELD
The delicate leaves of Herb-Robert balance perfectly with the dainty flower head. Here I chose an aperture that allowed both parts to be seen.

Project 2: Revealing texture

Texture is everywhere, from peeling bark to frozen puddles, waxy leaves and lichen-encrusted rocks. Surfaces can be rough or smooth, regular, or irregular. Even the calmest lake breaks into ripples when the wind disturbs the water. Occasionally, color and texture appear together, creating a sense of visual relief. Furthermore, texture can provide information about a subject: deep wrinkles indicate old age, for example, whereas soft petals suggest fresh young flowers.

Surfaces cry out to be touched, so trace the bumps and knots of a tree trunk with your fingers, or hold a piece of fabric next to your skin and relish the sensation. Next, step away from your subject and notice any wider patterns, tessellations, or shapes and colors. Look at the folds in the fabric as it rests on the table; consider the movement implied by the limbs of a tree. Humans have a tendency to look for likenesses in nature—contorted wood takes on the form of a face, while clouds resemble biblical figures—so be aware of this when planning your composition.

Emotional response

Adopt a meditative approach, and consider how these shapes, shadows, and surfaces make you feel. Does the twisted trunk make you feel sad? Does the fabric remind you of a piece of clothing you once wore and loved? Now try and communicate these emotions through your images. As we have seen, lines and colors have a strong psychological impact on the viewer, so use this knowledge to your advantage. It's worth noting that regular patterns, such as dips and ridges in corrugated metal, can be quite boring to look at, so introduce an extra dimension—try shooting surfaces where two colors clash, or include two surfaces with different textures, such as water lapping against a pebble on the beach.

Lighting direction

Before releasing the shutter, consider the impact of light on your chosen surface. Many textures can be enhanced by side lighting—if your subject is outside, shoot at either end of the day to take advantage of the long shadows. Alternatively, if your subject is indoors, use daylight from a side window, or experiment with lamps or off-camera flash. While it's tempting to add a quick burst with your camera's built-in flash, resist: more often than not this will produce harsh, direct light that will appear to flatten your textured surface. Furthermore, the soft, diffused light of a bright, but cloudy, day can be used to eliminate reflections or unwanted highlights—if the clouds are lacking, cast a shadow over the subject with your body or use a diffuser. Finally, photographers are often discouraged from shooting in the midday sun, but this unforgiving source can be perfect for emphasizing texture on vertical surfaces such as walls and stonework.

Whether you shoot peeling paint, fraying ropes, or rough skin, try to convey what it feels like to touch these textured surfaces. Introduce a sense of play to your photography, and encourage the viewer to join you as you explore.

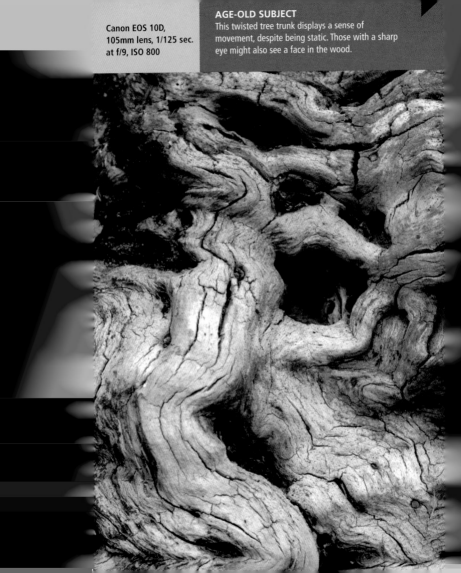

Canon EOS 10D, 105mm lens, 1/125 sec. at f/9, ISO 800

AGE-OLD SUBJECT
This twisted tree trunk displays a sense of movement, despite being static. Those with a sharp eye might also see a face in the wood.

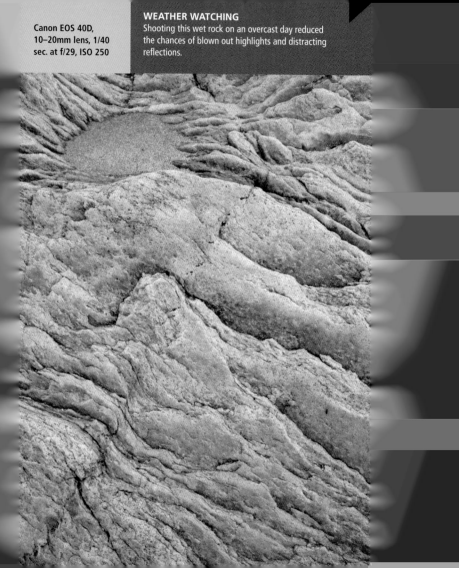

Canon EOS 40D,
10–20mm lens, 1/40
sec. at f/29, ISO 250

WEATHER WATCHING
Shooting this wet rock on an overcast day reduced
the chances of blown out highlights and distracting
reflections.

Canon EOS 40D,
105mm lens, 1/160 sec.
at f/13, ISO 200

DEEP SHADOWS
Late afternoon light elongated the shadows
and added a sense of depth to this patch of
peeling paint.

Project 3: Butterflies

On a warm summer's day the iridescent flash of a butterfly is guaranteed to catch the eye, and lift the spirits. Whether flitting along a country lane or basking in the heat of a tarmac road, these bewitching insects have been admired, captured, and mimicked for centuries. Their names sound like characters out of a fairytale: e.g., Adonis blue, Grizzled Skipper, and Brimstone. Similarly, their transition from caterpillar to chrysalis and then adult is the stuff of children's picture books.

Patient approach

Photographing butterflies in their natural habitat requires patience, perseverance, and a basic understanding of their biology and behavioral patterns. As cold-blooded creatures, they are at their least active during early morning and evening. The bulk of their activity (including feeding and courtship) takes place in the middle of the day. While this might seem like the best time to head out with your camera, it's the worst. When active, butterflies are much harder to approach. Like many insects, they flee if they feel threatened—sudden movement, or shadow, can send them up into the air, and out of sight.

At night, butterflies seek shelter under leaves or among grasses. Before the sun rises they are relatively still and occasionally covered in dew, preventing them from flying. At this stage they can be approached with relative ease—although it's important to watch where you place your feet, and avoid disturbing the vegetation. To maintain a suitable working distance, use a macro lens with a focal length of 100mm or more, or a short telephoto lens with an extension tube. In addition, a tripod or monopod is a must. Depth of field will be limited, so try a medium aperture (e.g., f/9) to begin with—this should keep the wings sharp, while throwing any background grass out of focus.

Carefully composed

Try to frame your subject so that the background is free of distractions. Highlights from blades of grass, colorful flowerheads, or stray twigs can all ruin an otherwise faultless composition. If necessary, use tweezers to remove loose items, and scissors to trim the tops of grasses. Natural history photographers occasionally move their subjects to new, clutter-free backgrounds, but it's best to leave any relocating to the experts. The welfare of the butterfly must come before any desire to photograph it.

Many butterflies are territorial, resting and feeding on specific plants such as Horseshoe vetch, Bird's-foot-trefoil, and Kidney vetch. By joining a local natural history group, or even an organization such as Butterfly Conservation you can gain access to specific sites and species, as well as learning fieldcraft and observation skills. Alternatively, focus on the butterflies and insects visiting your garden, encouraging them with nectar-rich plants such as buddleia, lavender, sweet rocket and Red valerian. Many butterflies have simple requirements: warmth, shelter, and food, making them undemanding, yet highly rewarding, guests.

Nikon D300, 150mm lens, f/9, ISO 200

KEEP YOUR DISTANCE
This small pearl-bordered fritillary was captured with a 150mm macro lens, allowing Ross to keep a respectable distance from the subject.

Nikon D70, 150mm
lens, f/5.6

CREATE ATTRACTIVE BLUR
Using an aperture of f/5.6 Ross was able to record
the background as an attractive blur, allowing the
marbled white to really stand out in the frame.

Nikon D300, 150mm
lens, f/7.1

KEEP IT SHARP
For sharp, shake-free pictures—such as this shot of a small
pearl-bordered fritillary—a tripod or monopod is a must.

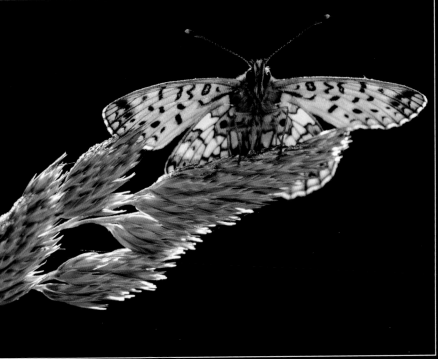

© Ross Hoddinott

Project 4: Abstract boat hulls

Boat hulls have fascinated me for many years now. While other photographers marvel at the billowing sails of yachts, I prefer to study the graceful underside of more humble craft. The peeling paint, rusty bolts, and warped wood of a boat hull tell the story of a tough life beneath the waterline. Once on dry land, the accidental beauty of these objects offers countless opportunities for abstract images. In addition, photographing a static subject allows you to concentrate on perfecting your composition, rather than worrying about shutter speeds or less technical concerns like your subject being jostled by the wind, or flying away!

Assessing the balance

After approaching a hull, I tend to walk around it, crouch down, and then stand up on my tiptoes to check the paintwork from every angle. When I've found an interesting area I use a piece of card with an aperture cut out of the centre to help refine my composition. Using this device allows me to block out any distracting elements, helping me to concentrate on the job in hand. Furthermore, I can assess the balance of the colors within the frame by moving the card up and down while considering the psychological impact of any adjustments. Blue is restful and indicative of the sea and sky—as a result, it often appears in my hull abstracts.

By studying the work of painters you can develop an instinct for color balance. Furthermore, by concentrating on a small area of paintwork for five minutes or more, you can often make out geometric shapes: triangles, squares and circles are particularly pleasing to the eye. When these forms appear, you can either show them in their entirety, or leave a small section out, forcing the viewer to mentally complete the shape.

Portrait or landscape

Before committing yourself to a composition, try turning the camera on its side. Most of us shoot in the landscape format because it's physically more comfortable than holding the camera in a portrait position (plus it's more akin to the way we naturally see the world). By attaching the camera to a tripod you can alternate between the two with ease. Furthermore, by using a firm support you can keep the focal plane of the camera level with the hull, ensuring everything is nice and sharp. At this point it's important to note that the hull of a boat has a generous curve, so you will need to select a relatively flat area, while using a narrow aperture to maximise depth of field.

Lighting considerations

When it comes to lighting, you have three main options: flash, diffused sunlight, or directional sunlight. I prefer the second option, which involves waiting for the sun to disappear behind a cloud—or using a diffuser—to soften the light and deepen the intensity of the colors. If you're after a three-dimensional effect, shoot when the sun is low in the sky, hitting the subject from the side and helping to reveal any texture.

Canon EOS 40D, 24–105mm lens, 1/250 sec. at f/16, ISO 100

FINDING BALANCE

As red is such a dominant color, I reserved it for the bottom third of the frame to prevent the blue from receding.

Canon EOS 40D, 105mm lens,
1/100 sec. at f/18, ISO 250

TAKING SHAPE
Looking for triangles and circles is something of
a habit of mine—here I included the point of the
triangle to complete the shape for the viewer.

Canon EOS 40D, 105mm lens,
1/125 sec. at f/14, ISO 200

MAKING LIGHT WORK
When the sun reappeared from behind a cloud
the grooves in the wood lit up, adding a sense of
three-dimensionality to the scene.

CHAPTER 10 POST PROCESSING

Introduction to post-processing

In order to realize the full potential of your photographs, you need to assess, organize, edit, and manipulate them on a computer—doing so will enable you to display them on the web, present them in the form of a print, share them with friends and family, or simply store them in an organized and logical way.

Computers and software

When it comes to choosing a computer, there are two main options: PC (Personal Computer) or Mac (Apple Macintosh). Which you choose will depend on personal taste, and how much money you have to spend (PCs tend to be cheaper). Whether you buy a PC or a Mac it's important to consider the speed at which the computer will process information—this comes down to the processor and the amount of RAM (Random-access Memory).

Processors and RAM

The operating speed of the processor is measured in GHz (gigahertz). In general the higher the number, the faster the speed. The issue is slightly complicated by the fact that many new machines have multiple processors, such as dual-core and quad-core. Again, the more processors, the faster the operating speeds. RAM is expressed in gigabytes (GB)—again, the higher the number, the faster the operating speed. This memory enables the computer to process applications, and perform multiple functions simultaneously.

Hard drive

The hard drive is where all of your digital images will be stored. A 320GB hard drive may seem large to begin with, but it's amazing how quickly it will fill up with images and computer programs. As a result, buy the biggest you can afford. If you run out of space, portable hard drives can be plugged in to your computer, providing more space—these can also be used to back up your files. Another way to back up is to use a DVD reader/writer. Most machines come with an inbuilt device, enabling you to burn pictures to DVDs for safekeeping.

Tip

Almost every digital file requires some form of enhancement, but it's important to concentrate on creating the best possible file at the moment of capture as any post-production is time-consuming and can sometimes degrade image quality.

Canon EOS 40D, 105mm lens, 1/100 sec. at f/7, ISO 200

SENSE OF COLD
In order to communicate the coldness of the ice to the viewer, I changed the White balance of the RAW file to Tungsten during post-processing.

Monitor

Space-hogging CRT (Cathode Ray Tube) monitors have now been largely superseded by sleek LCD (Liquid Crystal Display) models, which take up less space, and produce far fewer reflections. A screen measuring between 19 and 22in (482 and 558mm), with a minimum screen resolution of 1024 x 768 pixels, is ideal.

Before downloading your images to a computer it's worth making the effort to calibrate the monitor. Without knowing the true color of the image, you will not be able to adjust or print it with 100% accuracy. A good place to start is a software calibrator such as QuickGamma (for a PC) or SuperCal (for a Mac). If you intend to print a large number of images it's worth investing in a hardware color calibrator such as Eye-One Display 2 or Spyder 3 to provide consistent results.

Software

Once you have transferred your images to a computer, you will need to adjust and edit them to meet your needs. This can involve anything from tweaking the color or contrast to cropping and adding special effects. There are many image editing software programs available, some free, some expensive. Adobe Photoshop is possibly the most widely used, but Adobe Photoshop Elements is cheaper and will suffice for most photographers. Alternatively, you can purchase third-party software such as Adobe Lightroom (PC and Macs) or Aperture (Macs only).

Tip
To ensure consistency and color accuracy between external devices, your printer also needs to be calibrated (or profiled). Many manufacturers produce ICC (International Color Consortium) profiles for specific papers and inks, which take the guesswork out of color management.

PROCESSING PICTURES
In order for your pictures to reach their full potential you need to organize and edit them on a computer.

File formats

A file is a collection of data stored as a single unit. Each separate unit has its own file number, and each type of file has a particular suffix or extension to identify it: usually .JPEG, .TIFF, or .RAW. (Many camera brands have their own particular suffix for RAW files). Files can be opened, saved, deleted, compressed, and transferred from folder to folder or across devices. Each file type has its own strengths and weaknesses, and the format you select will often depend on the space left on the memory card and the intended purpose for the final image.

Storage and organization

By using a digital camera, it is likely that you will amass a huge amount of digital files quite quickly. It is therefore important to think about how to store and organize your images before things get out of hand. If you put every image you take into a single folder it will soon become time-consuming to locate a particular shot. One possibility is to keep files in folders based on the subject (e.g., England), and then create subfolders to further refine the category (e.g., England/London/Trafalgar Square). Third-party programs, such as Apple's Aperture and Adobe's Lightroom offer image management systems, allowing you to retrieve your files in a number of ways including using keywords or star ratings.

As soon as you start to build up your image collection, it's important to backup regularly. If you keep all of your images in one place—on a computer for instance—and it gets a virus or is stolen, all of your images could be irretrievably lost. To avoid this heartbreak, copy images to an external hard drive or use an online backup service, which will have the added benefit of storing images offsite.

JPEG files

JPEG stands for Joint Photographic Experts Group, after the software development team that originally created the format. The extension appears as .JPEG or .JPG after the filename, in either upper- or lowercase letters. JPEGs are compatible with almost all image-related software and work equally well on PCs or Macs.

The format uses "lossy" compression to reduce the size of the file, so that images are easier to send online, or take up less room on memory cards, for instance. "Lossy" compression involves the reduction of data in the file, leaving the image with less detail. Most cameras allow you to select JPEGs in various sizes, from Fine to Large—but it's best to use the maximum setting where possible. When the camera captures an image as a JPEG, the data lost through compression can never be recovered. In addition, certain attributes—suh as white balance and sharpening—are automatically assigned to a JPEG, and are tricky to alter at a later date. Each time a JPEG is opened, adjusted and resaved in a photo-editing program, the quality degrades slightly.

RAW files

A RAW file uses all of the data collected on the sensor when a picture is taken—the camera does not perform any form of compression. As a result, these files will give you the highest quality images with the most amount of information. A RAW file can be thought of as a film negative that can be "developed" on a computer to your exact specifications. Because all of the image data is retained, white balance, exposure, contrast, and sharpness can all be adjusted before converting the file to a JPEG or TIFF—although you must be careful not to save over the original file!

Any number of different versions can be made from the original image, without the RAW file changing. To make the most of these files, special conversion software is required—a basic package will come with your camera, but you can use third-party software such as Lightroom or Aperture. On the downside, RAW files take up more space on a memory card than JPEGs, and converting them to a more widely acceptable file format (such as JPEG or TIFF) can be time-consuming.

CONVERSION SOFTWARE
If your camera shoots Raw, then it will come with software to convert the files to TIFFs of JPEGs. The Digital Photo Professional software here is for Canon CR2 files.

TIFF files

TIFF is the acronym for Tagged Image File Format. Files are identified by the extension .TIF or .TIFF. The TIFF file format is widely used by graphic artists and the publishing industry as it uses "lossless" compression. In addition, TIFFs can be opened, adjusted, and resaved without sacrificing image quality.

However, certain attributes are automatically assigned to a TIFF file at the time of capture, and are tricky to alter at a later date. In addition, TIFF files are larger than JPEGs and take up valuable space on memory cards and computer hard drives.

Despite the drawbacks, photographers often shoot RAW, and save a separate file as a TIFF after converting it with image-editing software. When saving a TIFF you are usually faced with the option of either 8-bit or 16-bit—if you plan on carrying out more adjustments to the file, you should save it as 16-bit.

BACKUP
Photographers often convert RAW files into TIFFs and save them as separate files when backing up their images.

Improving tonal range

In an ideal world every "standard" image would contain a range of tones from black (shadows) to white (highlights), with plenty of information in between. As a result, every histogram would begin on the left-hand side, rise to a peak just short of the center, and then descend gradually to the right-hand edge, leaving a short flat stretch at the end. (For more information on interpreting histograms, *see page 62*.) Unfortunately, not all subjects and situations offer a standard distribution of shadows and highlights, and not all histograms display a full tonal range. Thankfully, it is possible to make tonal adjustments and improve brightness and contrast using two Photoshop tools: Levels

and Curves. Here we will look at using Levels to make global adjustments:

To improve tonal range using Levels

1) Open the image you wish to amend in Photoshop. Create a new Adjustment Layer: Layer > New Adjustment Layer > Levels. When the New layer dialog box appears, give the Layer a memorable name, such as Brighten, and press OK. By creating this new Layer, you can make adjustments without damaging the original file in any way.

TONAL RANGE
The histogram in the Levels dialog box shows the distribution of tones from black (shadows) to white (highlights).

2) When the Levels dialog box appears, you will see three controls (arrows) underneath the histogram. The first control (on the left) is the black-point slider, the center control is the mid-tones slider, and the last control (on the right) is the white-point slider. Using these three sliders you can adjust the overall brightness and contrast. Before proceeding, make sure that the Preview box (at the bottom of the Levels dialog box) is checked.

3) Move the left-hand slider (black arrow) to meet the beginning of the left-hand edge of the histogram (where the data begins). Now move the right-hand slider (white arrow) to meet the edge of the right-hand side of the histogram (where the data ends).

4) If you would like to lighten or darken the mid-tones in the image, you can move the central slider (gray arrow) slightly to the left or right.

5) Once you're happy with the results, click OK to apply the changes to the image. Now flatten the Layers: Layer > Flatten Image. Be sure to rename the file before saving it.

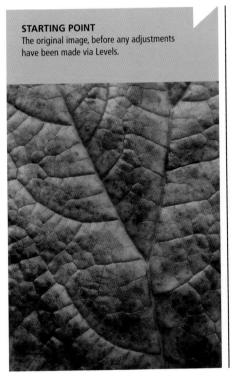

STARTING POINT
The original image, before any adjustments have been made via Levels.

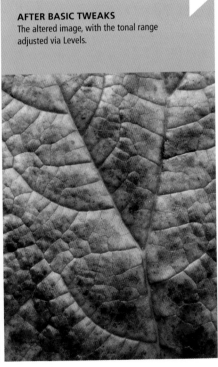

AFTER BASIC TWEAKS
The altered image, with the tonal range adjusted via Levels.

Cleaning up

Digital cameras feature a multitude of tools designed to reduce and remove dust from the low-pass filter covering your sensor. Unfortunately, despite huge advances in "cleaning" technology, each time you change lenses you run the risk of dirt entering the camera body and appearing as dark spots in your images. Thankfully, these blotches can be removed using one of four cleaning tools in Photoshop.

Cleaning tools

The Clone Stamp tool is perhaps the easiest to use, and is ideal for correcting small imperfections such as dust spots. This tool works by copying pixels from a specified source area and pasting them over the offending dirt. The Healing Brush tool works in a similar way, but also copies texture and blends colors to create a more natural-looking result. The Spot Healing Brush tool uses the same technology as the standard Healing Brush tool, but in this instance there is no need to specify a source —instead you just click and drag your cursor over the offending area. Finally, The Patch tool blends colors and copies texture, and is ideal for larger corrections. Here we will look at the Clone Stamp tool and the Healing Brush tool.

CLEANING THE SENSOR
Keep the sensor of your camera as clean as possible, but remember there are cleaning "tools" within Photoshop to help.

To use the Clone Stamp tool:

1) Open the image you wish to amend in Photoshop. Create a new Layer: Layer > New > Layer. When the New layer dialog box appears, give it a memorable name, such as Clean up, and press OK. By creating this new Layer, you can clone or move pixels without damaging the original file in any way.

2) Click on the Zoom tool and then click on the image until the offending area has been enlarged by 100%. (You can click on the Hand tool and move around the image by holding the cursor down and dragging it across the frame.)

3) Select the Clone Stamp tool from the toolbar by clicking on it. Now make sure that the Sample all layers box and the Aligned box, both in the top toolbar, are checked. Next choose a style and size of brush

from the drop-down menu in the top toolbar—choose a soft-edged version for areas of detail, and a hard-edged one for areas of uniform color. You need a brush slightly larger than the offending blemish.

4) Move the cursor (which will now be in the form of a circle) to a "clean" area, preferably next to the blemish, and similar in texture and color. Hold down the Alt key and click the cursor simultaneously. Now release the Alt key.

5) Move the cursor to the site of the blemish, cover it with the circle, and then click again to paste the pixels you collected in step 4 over the offending area.

USING THE CLONE STAMP TOOL
Before using the Clone Stamp tool, enlarge the image by 100% and a select a suitable-sized brush.

6) Use the Hand tool to move around the frame, and repeat steps 3–5 until all the dust marks have disappeared. Try to gather pixels from a fresh source every few clicks, or your circular stamping will form a pattern and start to look obvious. Now flatten the Layers: Layer > Flatten Image. Be sure to rename the file before saving it.

Healing Brush

The Healing Brush tool works in a similar way to the Clone Stamp, but also copies texture and blends colors to create a more natural-looking result.

To use the Healing Brush tool:

1) Open the image you wish to amend in Photoshop. Create a new Layer: Layer > New > Layer. When the New layer dialog box appears, give it a memorable name, such as Healing, and press OK.

2) Click on the Zoom tool and then click on the image until the offending area has been enlarged by 100%. (You can click on the Hand tool and move around the image by holding the cursor down and dragging it across the frame.)

3) Select the Healing Brush tool from the toolbar by clicking on it. Now make sure that the Sample

COMPLEX TEXTURES
The Healing Brush tool is ideal for cloning areas with complex texture and/or multiple colors.

toolbar, are ticked. Finally, make sure that the Source: sampled circle is checked, and the Source: pattern circle is empty (both in the top toolbar). Next choose a style and size of brush from the drop-down menu in the top toolbar. You need a brush slightly larger than the offending blemish.

4) Move the cursor (which will now be in the form of a circle) to a "clean" area, preferably next to the blemish. Hold down the Alt key and click the cursor simultaneously. Now release the Alt key.

5) Move the cursor to the site of the blemish, cover it with the circle, and then click again to blend the pixels and conceal the problem area. As the Healing Brush tool blends texture and color from the source and destination areas, the result should look more natural than using the Clone Stamp tool.

6) Use the Hand tool to move around the frame, and repeat steps 4–5 until all of the blemishes have disappeared. Now flatten the Layers: Layer > Flatten Image. Be sure to re-name the file before saving it.

Spot Healing tool

The Spot Healing Brush tool uses the same technology as the standard Healing Brush tool, but in this instance there is no need to specify a source-instead you just click and drag your cursor over the offending area.

Patch tool

The patch tool blends colors and copies texture, and is ideal for larger corrections.

Resizing

Whether you want to create prints for your living room wall, upload files to a stock library, or email images to friends and family, knowing how to resize your digital files will enable you to tailor each picture to the requirements of your audience. Here we will look at changing the size of your image using two popular methods: resizing and resampling. Using the resizing technique, the Pixel Dimensions remain unaltered and the file size is unchanged. By contrast, using the resample technique, pixels are created or removed to alter the Pixel Dimensions, and the file size becomes larger or smaller accordingly.

To resize an image:

1) Open the image you wish to alter in Photoshop. Open the Image Size dialog box: Image > Image Size. Make sure that the Resample Image box is empty, and the Constrain Proportions box is checked.

2) Now enter the desired height, width or resolution in the relevant box. As soon as you enter one figure, the other two will alter accordingly. Resizing an image in this way means that the Pixel Dimensions remain fixed.

3) Once you're happy with the new Document size, click OK to apply the changes to the image. Be sure to rename the file before saving it.

1) Open the image you wish to alter in Photoshop. Open the Image Size dialog box: Image > Image Size. Make sure that the Resample Image box is ticked, and the Constrain Proportions box is ticked.

2) Now enter the desired height, width or resolution in the relevant box. As soon as you enter one figure, the Pixel Dimensions will alter accordingly. Resizing an image in this way will make the file size larger or smaller.

3) Next to the Resample Image box you will find a drop-down menu offering five methods of interpolation. For most purposes the Bicubic option is ideal, but photographers looking to create large prints may find the Bicubic Smoother offers better results. The Bicubic sharper option can save valuable time when saving images for web display, but is best avoided for high-quality output. Finally, Nearest Neighbor, and Bilinear should both be avoided for anything other than web use. At this point it's worth mentioning that interpolation will make noise and image artifacts more noticeable, so only increase the file size when absolutely necessary.

4) Once you're happy with the Pixel Dimensions and file size, click OK to apply the changes to the image. Be sure to rename the file before saving it.

FIXED TERMS
When you re-size an image leaving the resample box empty, the Pixel Dimensions remain fixed.

Cropping

In an ideal world every photograph would be tightly composed, with no extraneous objects jutting into the frame, or obvious visual unbalance. Unfortunately, life isn't like: sometimes we can't get as close to a subject as we would like, or we might change our minds about the orientation of an image once we view it on screen. The fact is, no matter how hard we try some pictures still require a tighter crop to meet their full potential. (When using this technique it's important to remember that you will be discarding pixels, which might affect image quality.)

To use the Crop Tool:

1) Open the image you wish to crop in Photoshop, and make sure that it appears full screen: View > Fit

on Screen. Select the Crop tool from the toolbar by clicking on it.

2) At this point you have two choices. The first involves clicking on the image and dragging the cursor across the picture to highlight the area you want to retain. As a result, the section to be discarded will be shaded in gray. Now you can drag the corners of the flashing outline to enlarge or reduce the area you wish to retain. You can also position your cursor in the image area, and drag it around the frame to choose another area to crop, while retaining the same dimensions. Alternatively, you can use the drop-down menu to the right of the Crop Tool icon (in the top tool bar) to select an aspect ratio, such as 7x5in or 8x10in—you can also

CROP TOOL
The area to be discarded will be shaded in gray.

UNCROPPED FILE
The original uncropped file was composed in a landscape format.

enter your own values in the Width and Height boxes. Once the parameters have been set, you can click on the image and drag the cursor across the picture as before. (You can also position your cursor in the image area, and move drag it around the frame to chose another area to crop.)

3) If the crop is not to your liking you can cancel it by clicking the red Cancel current operation icon (in the top tool bar). If you're happy with the crop, you can either click on the green Commit current crop operation (in the top tool bar), select Image > Crop, double click on the area of the image you wish to retain, or press Enter/Return. Be sure to rename the file before saving it.

CROPPED FILE
The diagonal lines of the roof tiles worked better in the portrait format, so I set the aspect ratio to 7x5in and used the Crop Tool to change the orientation.

Sharpening

Due to the nature of the sensor, almost every digital image requires a certain degree of sharpening. Before applying the effect it's important to understand two things: firstly, an out-of-focus picture will never magically become pin-sharp, and secondly sharpening should be applied to an image at the end of the workflow process, immediately prior to output. Despite its rather misleading name, sharpening works by increasing the contrast along edges, and has nothing to do with improving detail or resolution. As a result, a sharpening filter works best with images already displaying good contrast, and fine detail—it cannot rescue an out-of-focus image. While sharpening makes the dark side of edges darker, and the light side lighter, over using this effect can lead to unsightly artifacts in areas of high contrast. At this point, it's worth noting that JPEGs are automatically sharpened slightly by the camera, so any extra effects should be used with caution. The amount of sharpening you apply depends on how you plan to use the final file (print, website etc), which is why it should always be the last step in the workflow process. In addition, as sharpening alters pixel values, it

TONAL RANGE
The histogram in the Levels dialog box shows the distribution of tones from black (shadows) to white (highlights).

is considered a destructive process, which is why it should be applied during output, and not as a part of the general image-editing workflow.

Photoshop offers four sharpening filters: Sharpen, Sharpen Edges, Sharpen More and Unsharp Mask (USM). The easiest, and by far most widely used, is Unsharp Mask. This particular filter works by creating a copy of the original image, blurring the second version slightly, sandwiching the two layers together, and then calculating the difference in tone between the two versions. This technique enables the program to identify areas of high contrast and make improvements to seemingly increase sharpness. (This method was frequently used in the darkroom, where photographers would sandwich two negatives with various degrees of sharpness together).

To apply Unsharp Mask (USM):

1) Open the image you wish to apply the Unsharp Mask to in Photoshop, and make sure that it appears full screen: View > Fit on Screen. Open the USM dialog box: Filter > Sharpen > Unsharp Mask. Check that the preview image is set to 100% (you can use the -/+ buttons to change the size).

2) The USM dialog box features three settings that can be individually adjusted: Amount, Radius, and Threshold. The first setting (Amount) determines the extent to which contrast is enhanced along edges. The second setting (Radius) dictates the size of the area to be affected. The final setting (Threshold) determines how much difference there must be in contrast between two pixels for the sharpening to be applied (if this slider is set to 0, then all of the pixels will be affected). Before proceeding, make sure that the Preview box is checked.

3) As the amount of sharpening required will depend on the intended output of the image (web, print, projector etc) it's hard to give exact figures, but to start with you might like to try: Amount 100%, Radius 1 and Threshold 0. In order to find the most appropriate settings, it's worth experimenting with the sliders, and checking the results in the Preview box.

4) Once you're happy with the Unsharp mask settings, click OK to apply them to the image. Be sure to rename the file before saving it.

UNSHARPENED FILE
The original RAW file has been adjusted, and converted to a TIFF, but no sharpening has been applied at this stage.

SHARPENED FILE
The Unsharp Mask filter has now been applied to the TIFF.

Aberration An imperfection in the photo caused by the optics of a lens.

AE (autoexposure) lock A camera control that locks in the exposure value, allowing an image to be recomposed.

Angle of view The area of a scene that a lens takes in, measured in degrees.

Aperture The opening in a camera lens through which light passes to expose the sensor or film. The relative size of the aperture is denoted by f/stops.

Autofocus (AF) A reliable through-the-lens focusing system allowing accurate focus without the user manually turning the lens.

Bracketing Taking a series of identical pictures, changing only the exposure, usually in half or one f-stop (+/-) differences.

Buffer The in-camera memory of a digital camera that temporarily holds image data before writing to the memory card.

Burst size The maximum number of frames that a digital camera can shoot before its buffer becomes full.

Cable release A device used to trigger the shutter of a tripod-mounted camera to avoid camera shake and internal vibration.

Center-weighted metering A type of

Color temperature The color of a light source expressed in Kelvins (°K).

Compression The process by which digital files are reduced in size.

Depth of field (DOF) The amount of an image that appears acceptably sharp. The range of this sharpness depends on three factors: the aperture of the lens, the chosen focal point, the subject-to-camera distance.

Differential focus The practice of teaming wide apertures (resulting in shallow depth of field) with a small, precisely controlled area of focus.

Dpi (dots per inch) Measure of the resolution of a printer or scanner. The more dots per inch, the higher the resolution.

Dynamic range The ability of the sensor/film to capture a full range of shadows and highlights.

Evaluative metering A metering system whereby light reflected from several subject areas is calculated based on algorithms.

Exposure The amount of light allowed to hit the sensor/film, controlled by aperture, shutter speed and ISO. Also the act of taking a photograph, as in "making an exposure."

Fill-in flash Flash combined with daylight in an exposure. Used with naturally backlit or harshly side-lit or top-lit subjects to prevent silhouettes forming, or to add extra light to the shadow areas of a well-lit scene.

Filter A piece of colored, or coated, glass or plastic placed in front of the lens.

F-stop Number assigned to a particular lens aperture. Wide apertures are denoted by small numbers such as f/2, and small apertures by large numbers such as f/22.

Focal length The distance, usually in millimeters, from the optical center point of a lens element to its focal point.

fps (frames per second) The ability of a digital camera to process one image and be ready to shoot the next.

Histogram A graph used to represent the distribution of tones in an image.

Hotshoe An accessory shoe with electrical contacts that allows synchronization between the camera and a flashgun.

Hotspot A light area with a loss of detail in the highlights. This is a common problem in flash photography.

Incident-light reading Meter reading based on the light falling on the subject.

Interpolation A way of increasing the file size of a digital image by adding pixels, thereby increasing its resolution.

ISO speed Describes the sensitivity of the sensor/film to light

.JPEG (Joint Photographic Experts Group) A universal image format supported by virtually all relevant software applications. JPEG compression can reduce file sizes to about 5% of their original size with little visible loss in image quality.

LCD (Liquid crystal display) The large screen on a digital camera that allows the user to preview images.

Megapixel One million pixels are equal to one megapixel.

Memory card A removable storage device for cameras.

Mirror lock-up A function that allows the reflex mirror of an SLR to be raised and held in the "up" position, before the exposure is made to reduce vibration.

Noise Colored photo interference caused by stray electrical signals.

Partial metering A metering system that places importance on a relatively small area at the center of the frame to calculate the exposure of the photograph.

PictBridge The industry standard for sending information directly from a camera to a printer, without having to connect to a computer.

Pixel Short for "picture element"—the smallest bits of information in a digital photo.

Predictive autofocus An autofocus system that can continually track a moving subject.

RAW The format in which raw data from the sensor is stored without permanent alterations being made.

Reproduction ratio A term used to describe the relationship between the size of your subject in real life, and the size it is recorded on the sensor/film. For example, a reproduction ratio of 1:2 means that the subject will appear half its actual size on the sensor or film.

Resolution The number of pixels used to capture or display an image. The higher the resolution, the finer the detail.

RGB (red, green, blue) Computers and other digital devices understand color information as a combination of red, green, and blue.

Rule of thirds Composition technique that places the key elements of a picture at points along imagined lines that divide the frame into thirds.

Selective focusing (see differential focus)

Shading The effect of light striking a photosensor at anything other than right angles incurring a loss of resolution.

Shutter The mechanism that controls the amount of light reaching the sensor by opening and closing.

SLR (single lens reflex) A type of camera that allows the user to view the scene through the lens, using a reflex mirror.

Spot metering A metering system that places importance on the intensity of light reflected by a very small portion of the scene.

Teleconvertor A lens that is inserted between the camera body and main lens, increasing the effective focal length.

Telephoto lens A lens with a large focal length and a narrow angle of view.

TTL (through-the-lens) metering A metering system built into the camera that measures light passing through the lens at the time of shooting.

TIFF (Tagged-Image File Format) A universal image file format that can be compressed without loss of information.

USB (universal serial bus) A data transfer standard, used by most cameras when connecting to a computer.

Viewfinder The camera's small window used to compose the picture, giving an approximate view of what will be captured.

White balance A function that allows the correct color balance to be recorded for any given lighting situation.

Wide-angle lens A lens with a short focal length and consequently a wide angle of view.

Working distance The space between the front surface of the lens, and the point on the subject where the lens is focused.

Useful web sites

Photography Publications
Photography books and Expanded Camera Guides
www.ammonitepress.com

Black & white Photography magazine
Outdoor Photography magazine
Features, tests and techniques
www.thegmcgroup.com

Digital Photography Review
Independent digital camera reviews and news
www.dpreview.com

ePHOTOzine
Photographic news, reviews, techniques and tips
www.ephotozine.co.uk

Equipment
Linpix Photography Mat
www.speedgraphic.co.uk

Waterproof Clothing
www.paramo.co.uk

Photographic accessories
www.novoflex.com

Sun compass
www.flight-logistics.co.uk

Lastolite Cubelite
www.lastolite.com

Wimberley Plamp
www.tripodhead.com

Bounce flash products
www.stofen.com

Adobe
Photo-editing software including Photoshop and Lightroom.
www.adobe.com

Apple
Photo editing software, notebook and desktop computers
www.apple.com/uk

Canon
http://www. canon.com

Nikon
http://www.nikon.com

Pentax
http://www.pentax.com

Sony
http://www.sony.com

Olympus
http://www.olympus-global.com

Panasonic
http://www.panasonic.com

Index

A

aberration
 chromatic 31
 spherical 31
AF point 72
angle of view 21
aperture 48
 and depth of field 58–61
 changing 60
 priority (AV) mode 61
 size 17
APS-C sensor 21, 24
autoexposure bracketing 52
autofocus
 (AF) 20, 68, 71
 failure 74
 continuous 72
 modes 72
 one-shot 72
auto white balance 92, 94

B

background 126, 127
 black 128
 blurring 131
 paper 129
backup 173
bags, camera 44
battery recharge performance 42
beanbags 37
bellows 32
blower 42
blurring 56
 background 131
boat hulls 162–165
Braash, Gary 118
bridge camera 18, 75
butterflies 158–161

C

cable release 39
camera
 modes 61
 shake 54

Canon

 EF 35mm f/1/4L USM prime lens
 26
 EF 100mm f/2.8L macro IS USM
 lens 27
 EF 1.4x extender 29
 EF-S 15–85mm f/3.5–5.6 IS
 USM zoom lens 26
 EOS 60D DSLR 19, 33
 Macro Ring Lite MR-14EX
 Macro Twin lite MT-24EX
care, for self 43
circles and spirals 116
cleaning the sensor 176
clips, string, and wire 38–39
clone stamp tool 176–177
close-up 12
 attachment lenses 31
 mode 61
clothing 44
cold conditions 43
color 136–147
 balance 146
 cast 92
 complementary 146, 147
 harmony 144
 impact with 138
 primary 142
 psychological effects of 138
 secondary 142
 temperature, understanding
 91, 92
 tertiary 142
 theory 138
 wheel 142–147
CompactFlash 34
composition 110–135
computers and software 168
contrast 65, 83
 creating 122, 124
 conversion software 172
creative eye 108
crop
 factor 21, 25
 tool 181
cropping an image 181–182
cubes 40
curves 115

D

data recovery packages 34
daylight balanced bulbs 89
depth-of-field 21, 58
 increasing 54
 preview button 20, 61
details, revealing 132
diffuser, using 89
digital
 compact camera 16, 33, 75
 file 168
 SLR (single-lens-reflex) camera
 19
 zoom 16
directing the eye 122
downloads, multiple 34
DSLRs, entry-level 33

E

electronic viewfinder 18
equipment 14–45
 caring for 42
 choosing 16–45
exposure 48–53
 and metering 46–65
 bracketing 51
 compensation 51, 100
 extenders/multipliers 29
extension tubes 30

F

file
 formats 171–173
 size 17
filter
 low-pass 42
 skylight 42
 ultraviolet (UV) 42
flash 96–109
 bounce 100, 104
 built-in 100
 dedicated macro 101
 diffusing 105
 exposure
 bracketing 105
 compensation 105
 external 100
 fill-in 99, 104

full 104
off-camera 100
photography, introduction to
 98–105
pop-up 100
ring 101
twin 101
flashguns, external 102–103
fly agaric 8–9
f-number 58, 68
f/stop 58
focal
 length 20
 long 24
 plane 30
 mark 61
 point 60
focus
 and depth of field 68
 differential (or selective) 70, 134
 manual 20
focusing 66–75
 distance 30
 on off-center subjects 71
 rails (or racks) 32
foreground and background
 126–135
freezing 56

G
golden hours 112
groundsheets 45
guide numbers 98

H
hard drive 168
healing brush 178–179
heat and humidity 42
histograms
 brightness 62
 RGB 62
 understanding 62–63
hue 144
hyperfocal
 distance 68
 point 68

I
illumination 78
interchangeable lenses 19
internal mirror 19
ISO 48
 sensitivity 17
 speed 54, 98
 understanding 54–55
isolating detail 64

J
JPEG files 171

K
Kelvins 92
Kelvin scale 91
KISS 112, 113

L
LCD screen 17
 articulated 33
 sunshade 45
lead-in lines 112
lens cleaning solution 42
lenses 20
 close-up attachment 31
 interchangeable 42
 long-telephoto macro 28
 macro 27
 prime 26
 short-telephoto macro 27
 standard 25
 supplementary 31
 telephoto 24
 zoom 26
levels, using 174–175
life size 12
light
 controlling 89–95
 direction 84
 factors 48
 hard and soft 80–81
 intense 82
 properties 78
 source 92
 quality 80
 understanding 76
 warm 82

lighting
 back 86, 87
 base 88
 front 86
 side 88
 top 85
lines
 horizontal 114
 psychology of 114
 vertical 115
Live View 75
local knowledge 110
loupe 108

M
macro 12
 lenses 27
magnification 12, 30
manual focus 20, 74, 75
manual (M) mode 61
Matisse, Henri 140
medium format 12
memory
 card reader 34
 cards 34
 MemoryStick 34
metering modes
 center-weighted 48
 evaluative 48
 matrix 48
 multispot 50
 multizone 48
 partial 50
 spot 48
metering patterns 50
middle ground 126
mirror lockup 20, 40
monitor 170
monopod 37
moss garden 10
multiple downloads 34

N
negative space 124, 125, 130
Newton, Sir Isaac 138, 142
Nikon
 AF-S Nikkor 24mm f/1.4G ED
 Wide-angle lens 21

AF-S Nikkor 50mm f/1.4G lens
25
Coolpix P100 18
R1C1 Wireless Close-up
Speelight System 103
noise 55

O
on location 110
optical
center 20
zoom 16

P
panning 56
parallax error 16, 18
patch tool 179
pentaprism 19
point-and-shoot camera 17
point of view, selecting 112
positive space 124
post processing 166–185
post-production software 92
posture 38
preshoot checklist 111
primary colors 142
processors and RAM 168
project ideas 148–165

R
rain protection 43
RAW files 92, 172
reflective
light readings 50
surfaces 74
reflector, using 90
repetition and pattern 133
reproduction ratio 10, 12
resampling an image 180
research 110
resizing an image 179
resolution 17
revealing texture 154–157
reversing rings 32
rhythm and pattern 118–125
right-angle finder 33
rule of thirds 112

S
saturation 144
scale 122
scrapbook 110
secondary colors 142
selecting focusing 135
self-timer 39
shadows 122
shapes, psychology of 115
sharpening an image 183–184
sharpness 68
short-telephoto lenses 27
shutter speed 17, 48
understanding 56–57
Sigma
DP2 16
EM-140 DG Macro Flash 101,
103
skylight filter 42
spot healing tool 179
steadying, the subject 38
storage and orgazination 171
storage wallet 34
study time 12
subject-to-camera distance 58, 60
sun compass 80
super
telephoto 19
wide-angle 19
symmetry and reflections 118

T
technical proficiency 10
teleconverters 29
telephoto 20
lenses 24
tertiary colors 142
texture 121, 124
Thomson, William 91
TIFF files 173
time of day 82
tonal range, improving 174–175
triangles and hexagons 116
tripods 35
carbon fiber 36
head 36
ball-and-socket 36
pan-and-tilt 36

reversible central column 36
selecting 36
weight 37
TTL (through-the-lens) metering
29, 32, 98

U
ultraviolet (UV) filter 42
unsharp mask, using 184–185

V
vibration
preventing 39
view, changing 33
viewfinder 19
electronic 19
visible spectrum 142
vital element 78

W
water, protection from 43
white balance
Auto (AWB) 92
using 92
wide-angle 20
lenses 21
wildflower portraits 150–153
Wimberley Plamp 38
windbreaks 40

Z
zone of focus 60
zoom lenses 26